IDIOT'S GUIDES
AS EASY AS IT GETS!

Digital Photography

by Shawn Frederick

ALPHA

A member of Penguin Group (USA) Inc.

ALPHA BOOKS

Published by Penguin Group (USA) Inc.

Penguin Group (USA) Inc., 375 Hudson Street, New York, New York 10014, USA • Penguin Group (Canada), 90 Eglinton Avenue East, Suite 700, Toronto, Ontario M4P 2Y3, Canada (a division of Pearson Penguin Canada Inc.) • Penguin Books Ltd., 80 Strand, London WC2R 0RL, England • Penguin Ireland, 25 St. Stephen's Green, Dublin 2, Ireland (a division of Penguin Books Ltd.) • Penguin Group (Australia), 250 Camberwell Road, Camberwell, Victoria 3124, Australia (a division of Pearson Australia Group Pty. Ltd.) • Penguin Books India Pvt. Ltd., 11 Community Centre, Panchsheel Park, New Delhi—110 017, India • Penguin Group (NZ), 67 Apollo Drive, Rosedale, North Shore, Auckland 1311, New Zealand (a division of Pearson New Zealand Ltd.) • Penguin Books (South Africa) (Pty.) Ltd., 24 Sturdee Avenue, Rosebank, Johannesburg 2196, South Africa • Penguin Books Ltd., Registered Offices: 80 Strand, London WC2R 0RL, England

International Standard Book Number: 978-1-61564-413-1
Library of Congress Catalog Card Number: 2013935157

15 14 13 8 7 6 5 4 3 2 1

Interpretation of the printing code: The rightmost number of the first series of numbers is the year of the book's printing; the rightmost number of the second series of numbers is the number of the book's printing. For example, a printing code of 13-1 shows that the first printing occurred in 2013.

Note: This publication contains the opinions and ideas of its author. It is intended to provide helpful and informative material on the subject matter covered. It is sold with the understanding that the author and publisher are not engaged in rendering professional services in the book. If the reader requires personal assistance or advice, a competent professional should be consulted. The author and publisher specifically disclaim any responsibility for any liability, loss, or risk, personal or otherwise, which is incurred as a consequence, directly or indirectly, of the use and application of any of the contents of this book.

Most Alpha books are available at special quantity discounts for bulk purchases for sales promotions, premiums, fundraising, or educational use. Special books, or book excerpts, can also be created to fit specific needs. For details, write: Special Markets, Alpha Books, 375 Hudson Street, New York, NY 10014.

Trademarks: All terms mentioned in this book that are known to be or are suspected of being trademarks or service marks have been appropriately capitalized. Alpha Books and Penguin Group (USA) Inc. cannot attest to the accuracy of this information. Use of a term in this book should not be regarded as affecting the validity of any trademark or service mark.

Publisher: Mike Sanders
Executive Managing Editor: Billy Fields
Senior Acquisitions Editor: Brook Farling
Development Editor: Kayla Dugger

Senior Production Editor/Proofreader: Janette Lynn
Book Designer/Layout: Rebecca Batchelor
Indexer: Angie Bess Martin

ALWAYS LEARNING PEARSON

I'd like to dedicate this book to three people.

First, to the two great men in my life: my dad, Donald K. Duman (March 3, 1934–January 30, 2012), and my grandfather, John R. Frederick (March 8, 1913–January 2, 2013). Both were very instrumental in my becoming a photographer, educator, and explorer of light. Their unwavering support and guidance have played a key role in my life.

And to my mother, Patricia M. Frederick. Mom, you're my true moral compass, and none of what I do would be possible without your love and support.

I appreciate and love you all.

CONTENTS

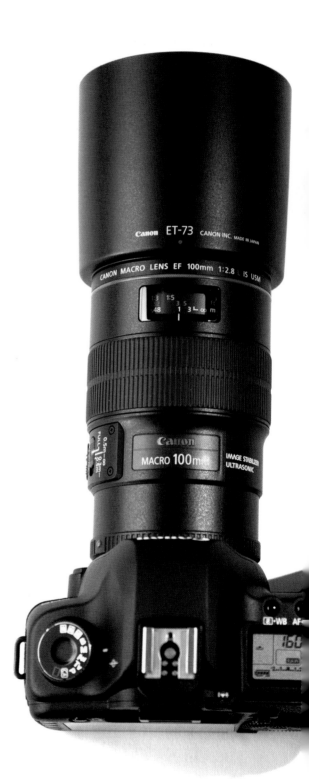

Part 2: The Shots 60

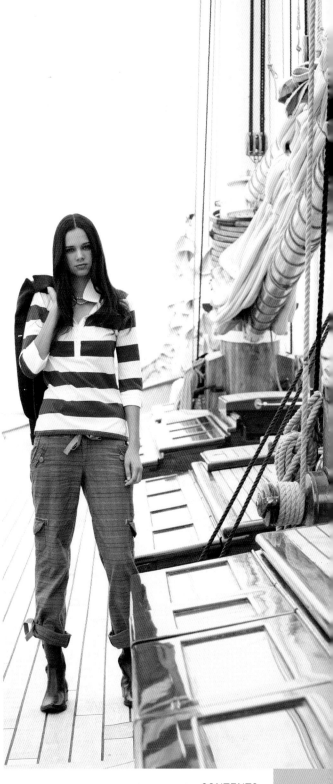

Part 3: The Projects 158

INTRODUCTION

Did you ever look at a magazine, a book, or even a friend's photo album and say to yourself, "I wish I could take pictures like that"? Well, you can. It isn't all that difficult to shoot high-quality photographs once you master a few tricks of the trade and learn to operate a DSLR camera. However, it isn't going to happen in a day, a week, or a month. Digital photography takes patience, practice, and perseverance. And it also doesn't hurt to learn from a pro.

Idiot's Guides: Digital Photography provides the necessary tools to enable you to become the kind of photographer you want to be. The book begins with all the basics you need to know to operate a DSLR camera with confidence and assurance. Once you know what the camera can do, it's up to you to put those principles into action. As an award-winning photographer, I can show you the best ways to shoot the kind of photos you want. Not only do I give you tips on how to use your camera, but through a wide variety of my own photographs, I offer the kind of visual support you need to get the best shots in every situation.

The topics in Part 1 cover the basics concerning digital photography. Some of the subjects include the camera's settings, the use of light (both natural and artificial), the art of metering and focusing, ways in which composition affects the final results, the use of supplementary equipment, and how to prepare and set up for a shoot.

Part 2 looks at different types of photo shoots—such as automobiles and motorcycles, family and kids, landscapes, sports, still life/fine art, backlit subjects, sunsets and sunrises, night shots, silhouettes, and dynamic action—and ways to deal with and direct your subjects. I also point out the small mistakes that can lead to less-than-desired results, as well as provide visual examples of the right ways to compose and shoot.

In Part 3, I walk you through some projects that can make you a more versatile and complete photographer. Want to learn how to create motion blur, work with reflective and mirrored subjects, or even process your image files? You'll find that information in this part.

Idiot's Guides: Digital Photography is an indispensable tool for both the new photographer and those looking to take their camera work to the next level. It will help you reach a point where you can proudly show your photographs without reservation and no longer have to say, "I wish I could take pictures like that." Because now you can.

ACKNOWLEDGMENTS

It's with great pleasure I acknowledge the following individuals for their contribution and dedication both to this project and to my profession at large.

First off, a special thank you to my partner in life, Anne-Marie Gajer. Thank you so much for going on this journey through life with me. You are my true north and guiding light. And thank you for access to your LittleButtons.com baked goods for our photo shoot. Your cakes, pastries, and confectionary are second to none.

Thanks to my writing partner, Bill Gutman. Without your tireless guidance and dedication to this project, it would have never been completed on time and in the detailed and informative manner I believe it is. So thank you again Bill—you're indeed a true treasure.

To my agent Marilyn Allen, thank you very much for steering this project and for keeping it on its rails throughout the entire process. You are very appreciated.

And to Brook Farling, my acquisitions editor and the real project cheerleader, thank you immensely for maintaining your bold vision and for keeping the project on track month after month. And to my editor and designer, Kayla Dugger and Becky Batchelor, you are both true professionals to work with and have no doubt created a wonderful series of books.

To all of my photographic subjects that put up their time, energy, and/or their likeness to help me with this book: Laura Conley; Johnny Boy Gomes; Ross Williams; Dylan Kwasniewski; Steve Rapp; Johnny Mosley; Jimmy Costas; Roland Sands; Kane Friesen; Jennifer Wooten; Adam Jewell; Nancy Mason; Bobby Friedman; Tina Martin; Ken Caldwell; and my great friend, Mike "The Godfather" Metzger. Thank you all for your friendships and willingness to help me whenever I've asked.

I'd also like to say a huge thank you to my dear friends Tim and Sharise Clegg and their beautiful children, Jacqueline and William, for allowing me time to shoot their pictures for this and many other projects.

I'd like to also acknowledge Rick and Denise Erkeneff and their beautiful girls, Eleanna and Emma. You have tirelessly helped me throughout my career and have been available to my asking every time—thank you again!

An immense thank you to newly married couple Steven Klein and Alexandra Kummer-Klein for allowing me access to your wedding and to showcase the photos in this book.

To Richard Wright, your friendship and guidance is undeniable and words cannot truly say how appreciative I am. Thank you.

Thanks to my dear friends David and Donna Pu'u; your friendships and contributions to this book are incredibly appreciated.

To my friends, collaborators, cohorts, and soldiers in arms—Erin Grayson, Art Cohan, Josh and Holly Schoenfeld, Tyler Swain, Brandon McCartney, Dan Coronado, and Shannon Haymes—I say thank you to you all. You have made my career the joy that it is and continues to be.

To my Hawaiian family, Duane Desoto and Sam and Ezra Rodrigues, thank you for all of your help throughout the years—you truly are genuine souls, and I very much appreciate everything you have done for me. Aloha!

Thanks to both my models from the sailboat shoot, Katie and Amanda, and to Troy Sears for allowing us access to his sailboat, *The America*. It was a true treat to shoot aboard her.

THE BASICS

Before you jump into trying the shots and projects in this book, you need to learn the basics of digital photography. First, I provide a brief history on the DSLR to give you an idea of how technology has changed the ease of use (and the price!) of digital cameras. I also look at the special features of a digital camera, such as auto settings; the LCD monitor; and menu, histogram, and info buttons.

However, the basic tenets of photography have not changed over the years, so I also take you through some essentials that every photographer should know—from shutter speed, to aperture settings and lenses, to the all-important aspects of lighting.

I end this part by bringing the different pieces of photography together to talk about how you can set up a home studio as well as a location shoot.

While reading through each section, have your camera by your side so you can practice changing your settings, see firsthand the choices that come up on your menu, and simply become more comfortable handling the camera. Also, there's no substitute for actually going out and shooting. You can begin that anytime, even as you work on learning the basics. The nice thing is, you won't waste film, as in the old days—you can simply check the results on your LCD monitor, delete anything you don't want to keep, and move on.

In this part, I give you the foundation you need to become a confident and creative photographer.

A BRIEF HISTORY OF THE DSLR

The digital single-lens reflex (DSLR) camera combines features of the single-lens reflex (SLR) camera with the addition of a digital sensor, which eliminates the need for the longtime staple of the photographic industry—film. With reflex cameras, the light travels through a single lens, and a mirror reflects some of the light through the viewfinder. The image seen though the viewfinder is the same captured by the camera's sensor—in other words, what you see is what you get.

The DSLR has revolutionized photography. First of all, you aren't limited by the number of photos you can capture on a roll of film. Digital cameras can literally shoot and save hundreds of photos. When you had a roll of film developed, you had to take everything—the good, the bad, and the ugly. With a digital camera, you can print or select only the best and discard the rest.

Today's cameras are loaded with features that enable the amateur photographer to shoot professional-grade photos. But it isn't just a matter of point and shoot. You still have to know your camera very well, then apply the basics of photography—such as using light, metering correctly, and knowing the meaning of good composition—to shoot like a pro. Still, it can be done.

The DSLR offers a wide variety of interchangeable lenses and other accessories to not only make your job easier, but to help you use this fine piece of photographic equipment in the most optimal way. In addition, you can use a variety of software programs and applications to edit and enhance your photographs. Sound exciting? It is. If you want to become the best photographer you can be, today's digital photographic equipment puts that opportunity at your fingertips more than ever before.

HOT TIP

The prices of today's DSLRs vary widely—you can find some for less than $400, or you can spend into the thousands. Depending on your budget and how you plan to use your camera, you should always buy the best you can afford. Though low-end DSLRs can shoot fine pictures, the more expensive cameras have more features, better lenses and sensors, and greater versatility. The choice is yours.

Timeline

1969: A digital sensor is used for imaging purposes.

1975: The first digital still camera is developed.

1981: A prototype analog electronic camera that features interchangeable lenses and an SLR viewfinder is made.

1991: Kodak releases the first commercially available and fully digital SLR, the DCS-100. Cost: approximately $30,000.

1999: Nikon introduces the D1, the first DSLR to compete with film cameras.

2000: Fujifilm releases the FinePix S1 Pro, the first DSLR marketed to nonprofessionals.

2003: Canon introduces the EOS 300D. With a list price of $999, it's the first DSLR directed at the consumer market. Others soon follow suit.

2009: Nikon introduces the D90, the first DSLR to feature video recording; Sony releases the Alpha 850, the first accessible full-frame DSLR for amateur photographers.

2012: The first DSLR featuring a touch screen came on the market.

UNDERSTANDING SENSOR TYPES

The sensor is the core of all digital cameras. It essentially replaces film, but its presence hasn't changed the mechanics of the camera. In the past, the image would be recorded on film. Now, once you open the shutter curtain, light penetrates the sensor and records the image.

CCD Sensor vs. CMOS Sensor

The charge-coupled device (CCD) and the more common complementary metal-oxide semiconductor (CMOS) are the two primary types of sensors in use today. The CCD sensor is far more expensive than the CMOS and consumes the most power. It also has a somewhat higher resolution than the CMOS—and therefore produces better picture quality—though not high enough to be noticed to most people. The reason for this is that the CCD sensor produces "lower-noise" images.

WATCH

Digital noise produces speckled pixels (pixel elements) of color in an image that can give it a grainy look.

The CMOS sensor is much more affordable and uses less power to operate when compared to the CCD. Though the picture quality might not quite have the same high resolution, again, most people won't notice the difference. CMOS sensors produce very fine images and have become so popular, they are now found in many mobile phones with cameras.

APS-C Sensor

An advanced photo system type C (APS-C) sensor is used today in less-expensive cameras. Though it is smaller than the CCD and CMOS sensors, the resolution in the camera is still very good. With this sensor, you gain a bit of focal length in your lenses. For example, if you put a 50mm lens on a full-frame sensor camera, you get the full 50mm perspective; however, if you use the same lens on a camera with an APS-C sensor, you'll have a focal length of approximately 80mm. Thus, with the APS-C sensor, you'll lose the outer edges of your composed frame.

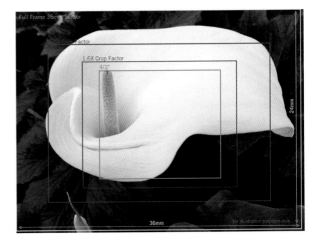

The Importance of Sensor Size

The rule of thumb is to purchase a camera with the largest sensor ratio you can afford. A full-frame, 1-to-1 ratio is ideal. Because the sensor—regardless of ratio—is rectangular and the lens element is round, know that the larger the sensor, the more information the sensor can record from the image circle of the lens.

A full-frame sensor.

But smaller sensors aren't necessarily a bad thing for an advanced amateur photographer. Most images are sharpest at their center, with the quality degrading progressively toward the edges, so a cropped image from a smaller sensor is discarding the lowest-quality portion of the image first. In some cases, this can actually help the overall quality of the image when using lower-quality lenses, which normally have the poorest edge quality.

HOT TIP

Be aware of the sensor size when purchasing a camera, because it will influence the size, type, and quality of the lenses you use.

Keeping Your Sensor Clean

All image sensors get dirty from time to time, which can result in annoying specs of dirt showing up on your otherwise-perfect image. Like with other components of your camera, there are right ways and wrong ways to clean the image sensor. If you clean it incorrectly, you can do critical damage to the sensor. To avoid this, here are some steps you can take to safely clean your image sensor:

- Flip up the SLR mirror to access the sensor. Most cameras have a sensor cleaning mode that allows you to do this.

- Use a blower bulb to gently blow air onto the sensor. *Never* use a brush, compressed air, or a lens tissue to clean the sensor.

- If the air from the blower bulb doesn't do the trick, you can purchase a commercially available sensor cleaning kit made for cleaning sensors. You also have the option of taking your camera to a professional, who can safely do the job for you.

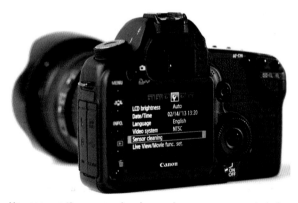

You can use the sensor cleaning mode on your camera to help you keep your sensor free of dirt.

INTERPRETING DPI AND PPI

The terms *DPI* (*dots per inch*) and *PPI* (*pixels per inch,* or *pixel density*) can often be confusing to the amateur photographer. In a nutshell, you use the term *DPI* to describe the quality or resolution of the image when it's printed (or outputted), and you use the term *PPI* to describe the quality of the final image file you've taken with your camera.

When talking about DPI and PPI, you must first consider the most simple of photography basics: how big do you want the final, printed image to be? Both the PPI and the DPI can affect the final quality of a printed image.

It doesn't matter whether it's a small 4 × 6 image at 72 DPI you plan to send in an email or a larger 8 × 10 image at 300 DPI you plan on printing from your desktop printer—the higher the PPI in the original picture file, the better the overall tone and quality output of the final printed image. The colors will look better, and the blending of shades and tones will appear smoother. The more dots per inch in the printed image, the smaller the dots will be and the finer the image quality will appear.

In most cases, the DPI rating of a majority of home ink-jet printers is in the 1000+ range. In essence, this represents what is called a *blended dot,* meaning it overprints a single dot with different colors to get the color that's required. In order to get the best-quality print of your photograph, make sure you have a printer that performs this blending at the highest level so there's little to no difference between the file and the printout of the image.

When it comes to PPI, the higher the number of pixels per inch in the image you've captured with your camera, the higher the quality of your image. PPI also affects the final size output of the image and the quality of your final printing when you're putting your image on paper. If you have too few pixels, your image will look as though it has jagged lines and won't be sharp, crisp, and clean.

HOT TIP

This may help differentiate between DPI and PPI: if someone requests a photo at a certain DPI, they are asking you to print an image at a certain resolution or quality. For example, if they ask you for a picture printed at 300 DPI, there will be 300 dots in each square inch of that printed image. If they request an image that is 300 PPI, they are asking for the image file to be a certain size.

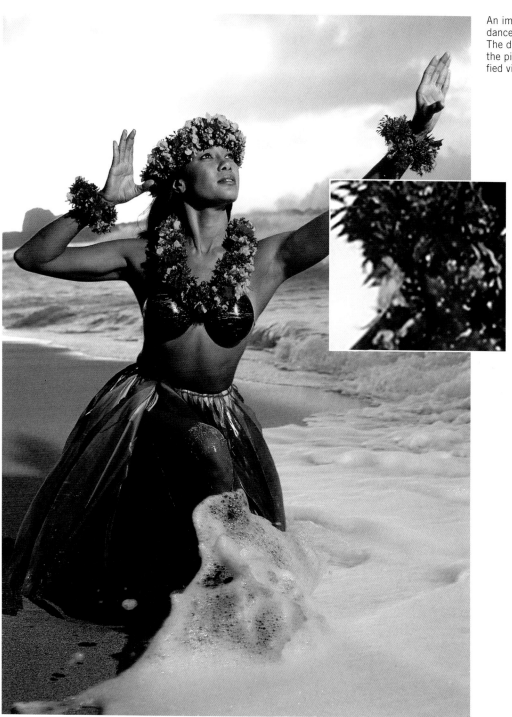

An image of a hula dancer at 300 DPI. The display box within the picture is a magnified view of the pixels.

SHUTTER SPEED

Everyone who has ever owned a camera knows about the shutter. It's the shutter that determines how much light your digital sensor is exposed to and for how long. That length of time is what's called *shutter speed*. Basically, the longer the shutter remains open, the more light is allowed in. This is something over which you have complete control. To get a properly exposed photo, you must have just the right amount of light. Otherwise, the photo will be over- or underexposed.

HOT TIP

Many of today's DSLRs have two shutter-release buttons—one on top for horizontal or landscape photos, and one on the side so you can shoot vertical or portrait-style photos. Be sure to check your camera to see if your have the second shutter button.

Using Your Shutter

It's very easy to change the shutter speed when your camera is in manual mode—just turn the command dial and watch the numbers change on the LCD status screen. Shutter speed is generally measured in fractions of seconds. So a shutter speed of 5000

means that the shutter will open for just 1/5000 of a second. Shutter speed is considered to be "long" or "slow" when it is slower than 1/60 of a second. This number was chosen because the average person can only hold a camera with a standard lens (between 35mm and 70mm) steady for 1/60 of a second or faster without blurring the picture or needing to secure the camera to a tripod.

To gauge the slowest shutter speed you should use with a particular lens and no tripod, just look at the size of the lens. For example, a 300mm lens should be held at shutter speeds of 1/300 of a second or faster. Faster shutter speeds of 1/500 of a second or more are generally used when shooting moving subjects so you can freeze or stop the motion in the image.

WATCH

Remember, the longer the focal length of the lens, the heavier it becomes and the more need you'll have for a sturdy tripod or stabilization device.

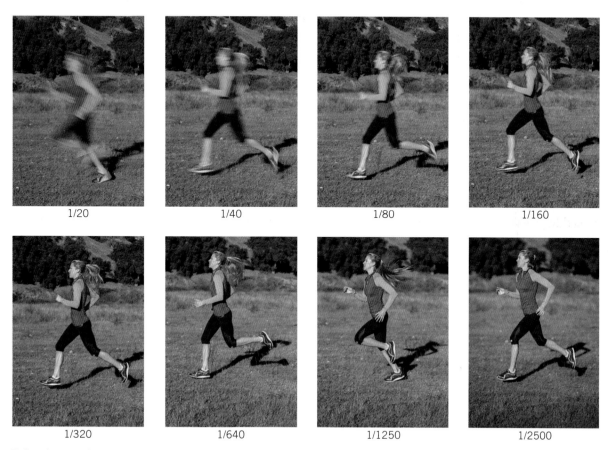

| 1/20 | 1/40 | 1/80 | 1/160 |
| 1/320 | 1/640 | 1/1250 | 1/2500 |

Various images of a runner in motion taken at different shutter speeds.

Making Other Adjustments to Balance Shutter Speed Settings

While a fast shutter speed allows you to freeze fast action, it also permits a lesser amount of light to enter the camera. Therefore, you must compensate shutter speed with other adjustments, such as the aperture, or the image may turn out too dark. Conversely, while a slow shutter speed will compensate for low-light conditions, any movements your subject makes may blur the photo. Again, you must make adjustments to your other settings to avoid this issue.

Sample Shutter Speeds

When Shooting ...	Use (in seconds) ...
Sporting events	1/500 to 1/2000
Kids	1/250 to 1/1000
Motion blur	1/30 and lower
Fireworks	1 to 5
Night shots	2 and higher
Waterfalls	5 to 8

APERTURE

Your lens's aperture setting plays a large role in capturing the image you want. The aperture is a diaphragm located within the lens itself that allows the user to control the amount of light passing through it. The larger the aperture, the more light is able to reach the image sensor. The aperture's movements are closely related to the shutter speed movements when deciding on an exposure setting for a particular photo.

As you'll recall from the previous section, shutter speed is a measure of how long the shutter curtain remains open to allow light into the camera. Because both the aperture and shutter speed settings affect how much light can enter the camera, increasing one while decreasing the other can actually result in the same amount of light be allowed into the camera for a shot.

The numerical aperture setting determines just how much the diaphragm will open when the shutter-release button is pushed. The aperture directly controls the amount of depth of field you'll have in your photo. Lens aperture settings are measured in f-stops, or focal lengths. A smaller f-stop indicates a larger lens opening, while a larger f-stop value indicates a smaller opening. For example, an aperture setting of f/22 would lead to a smaller opening than an f/2.8 setting.

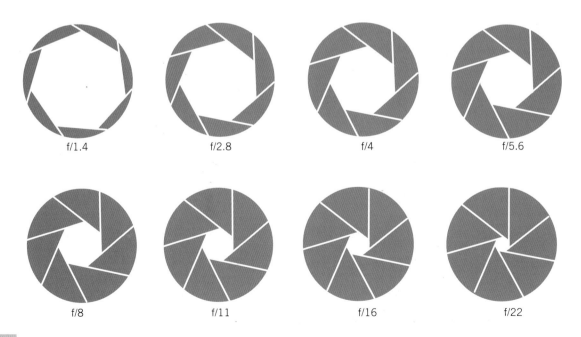

f/1.4 f/2.8 f/4 f/5.6

f/8 f/11 f/16 f/22

A flowering tree shot at different aperture settings. As you can see, the larger the aperture setting, the less light is able to reach the sensor.

f/2.8

f/8

f/16

f/32

DEPTH OF FIELD

Depth of field refers to the relative sharpness of subjects at varying distances from the camera and is directly related to the aperture setting you choose for your shot. It is the portion of the image before and beyond your focus point that is still in focus. Normally, you focus on one subject and make it as sharp as possible. With a smaller f-stop setting, subjects at other distances—whether in front of or behind the main subject—are out of focus and not as sharp. The area of perceived or acceptable sharpness is within the depth of field. At a higher f-stop setting with a larger depth of field, pretty much all of the areas in the shot will appear in focus.

Considerations for Depth of Field

When shooting a large subject area, such as a landscape, you want a large depth of field using an f-stop setting such as f/32 so the entire image appears in focus. Conversely, with an individual portrait, you strive for a smaller depth of field to create a clean visual separation between the subject and the background, so you might use an f-stop like f/5.6. You must also consider the distance of your subject from the camera. The closer you are to the subject or main focal point, the less depth of field is possible.

To get a basic understanding of depth of field, try holding an object, such as a coffee cup, at arm's length. Focus on it with your eyes and notice how much of the surrounding environment you can see. Now slowly bring the object toward your face. Take a look at the halfway point and then when it's as close to your eyes as possible while still being in focus. At each stop, you'll see less of the surrounding environment because your depth of field is shrinking.

F-Stops, Shutter Speed, and Lens Size

Both f-stops and shutter speed have a strong connection to depth of field. Larger f-stops, such as f/11, require slower shutter speeds in order to produce images with a larger depth of field. Conversely, smaller f-stops, such as f/4, allow for faster shutter speeds and produce images with a shallower depth of field. Lens size also plays a role when you consider depth of field. The higher the magnification factor of the lens, the smaller the depth of field will be, even with large f-stop settings.

HOT TIP

Do the following exercise with each lens you have and learn how they all work in various situations. You'll find that the longer the lens becomes, the more the depth of field appears to decrease.

Here's an exercise that will really allow you to understand depth of field:

1. Set up five dominoes (or anything similar in size that will stand up) up to 1 inch apart, making sure to slightly stagger them so you can see all of them.

2. Fit your camera with a midrange lens (like an 85mm) and set it on a tripod, adjusting the tripod's height so the camera is as close to the dominos as possible while still keeping the first domino in focus.

3. Set the mode to manual and take a picture at the shallowest aperture your lens will allow—if you can get to f/2.8 or smaller, great.

4. After you take the picture and without moving anything, reset your aperture to the next complete f-stop from where you began. Repeat this step all the way to the largest aperture value your lens has, which should be either f/22 or f/32.

When you see the results, you'll understand how depth of field varies and how you can then begin to control it.

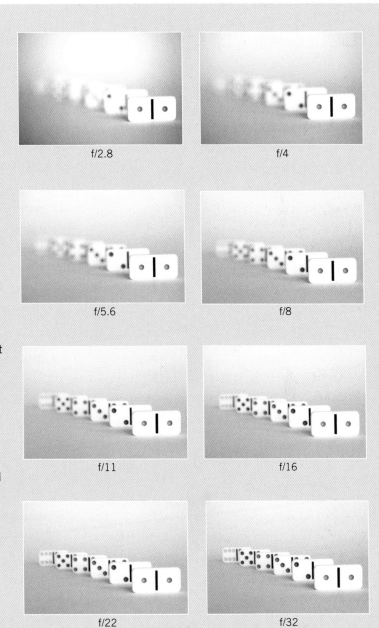

f/2.8 f/4

f/5.6 f/8

f/11 f/16

f/22 f/32

See how the depth of field changes with each aperture setting?

ISO READINGS

The term *ISO* refers to the degree of sensitivity your camera has to light. Originally a measurement used for film, ISO sensitivity now refers to a digital camera sensor's level of sensitivity to light.

ISO Numbers

With the old film cameras, different films had different ISO numbers to indicate the speed and light sensitivity of the film. The same numbers now refer to the sensors on DSLR cameras. A high ISO setting makes your camera more sensitive to light, which results in better performance in low-light conditions; a low ISO setting makes your camera less sensitive to light but produces sharper, crisper images with less distortion or "noise." Depending on the camera, numbers can range from 50 to 6400 and beyond.

HOT TIP

Most digital cameras allow you to manually adjust your ISO settings, while many also have an auto-ISO mode. The way this works on individual cameras may vary, so check your camera's instruction manual for details.

When you increase the ISO number, you give yourself the ability to capture images in lower light; however, that can also lead to some problems. Your camera picks up sensor noise at higher ISO numbers, which can give your images a grainy look. This is a case where the quality of your camera may make a difference. The better the quality of the camera and its digital processing unit, the higher you can raise the ISO setting without experiencing that grainy look. Inexpensive digital cameras may start producing a grainy look with an ISO setting as low as 400, while high-end cameras can still take great images with ISO settings of 800, 1000, and perhaps even 1600.

Experimenting with ISO Settings

ISO is the third element—along with shutter speed and aperture—that determines how your camera captures light for your exposures. Therefore, you need to learn how to integrate ISO with shutter speed and aperture to achieve the best results. When you increase the ISO number, you can also to use a faster shutter speed, which lessens the chances of taking blurry pictures and makes it easier to achieve better results when shooting fast-moving subjects. Increasing the ISO number also allows you to use a high aperture setting and thus have a greater depth of field.

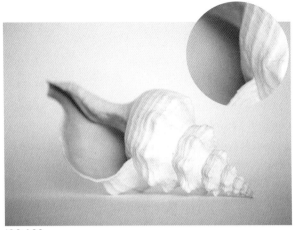

ISO 100

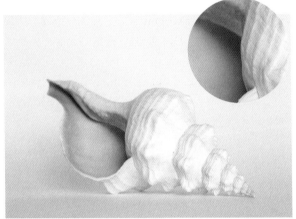

ISO 1000

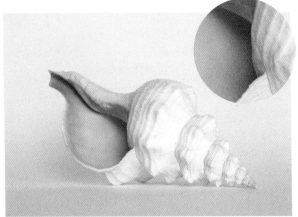

ISO 6400

Experiment with the ISO settings on your camera to learn at what point you notice sensor noise. That way, you'll know your camera's limits, which will help you to combine ISO with your aperture and shutter speed settings correctly.

And if you care to explore a bit, software programs are available that can help you reduce or even eliminate much of the noise in your photos, which enables you to shoot at a higher ISO setting than you normally could. Modern technology can sometimes be your best friend when using your DSLR.

ISO Number	Light Conditions
100	Bright
200	Cloudy or overcast
400 and 800	Dim, like at sunset
1600 and above	Indoors or at night

Photographs of a shell taken with various ISO settings. See the difference in the close-up and the amount of noise in each?

AUTO SETTINGS

The modern DSLR is an amazing piece of photographic equipment that does many things its predecessors did not. You, as a photographer, now have many options when it comes to customizing your settings for the photo you want. However, if you don't feel comfortable making all those decisions on your own yet, the camera has built-in auto settings that don't require you to do much more than push the shutter button and take your shot. Let's look briefly at these auto settings and see how some can be integrated with your own individual settings to get the best photo possible.

Automatic or Auto

When you choose automatic, all you have to do is set your camera and go to work. It will give you the correct exposure by adjusting the shutter speed, aperture, and the rest for you. As I mentioned earlier, this setting will give you good photos that are nearly always properly exposed, but it won't give you those creative, one-of-a-kind images you'll want to shoot once you gain more experience.

Program Automatic

With this setting, your camera will set your shutter speed and aperture automatically but still allow you to control other settings, such as ISO (which, if you can recall, determines how sensitive your sensor is to light).

Shutter Priority

By selecting shutter priority, you have the option of setting the shutter speed and ISO, while the camera sets the aperture. This can come in handy when shutter speed is the top priority, such as when you are shooting fast-moving objects or people.

Aperture Priority

Aperture priority is basically the opposite of shutter priority—it allows you to set the aperture and ISO, while the camera takes care of the shutter speed. This is a setting you may want to use when aperture is the most important consideration for the photo you are about to shoot. You would most likely use this setting when you want to be sure to control depth of field.

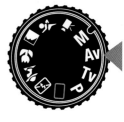

Scene Modes

When you are photographing certain types of scenes—such as action sports, landscapes, or night shots of fireworks—putting your camera in a certain scene mode allows your camera to make adjustments to aperture and shutter speed and set the exposure automatically for the conditions under which you will shoot. The better you become at choosing your own settings, the less you'll need this type of mode. The following are some common scene modes you'll see on your digital camera:

Action/sports mode: This mode is ideal for shooting fast action settings in good light. Your camera will create the more shallow depth of field that leaves a subject in focus and the background less in focus.

Landscape mode: This mode is best for shooting wide-angle shots where everything needs to be in focus, such as mountains or any large area where a larger depth of field is desired.

Portrait mode: This mode makes adjustments that will optimize skin tones and create the shallow depth of field that's desirable when shooting in a portrait setting.

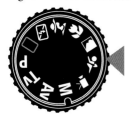

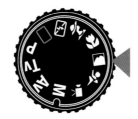

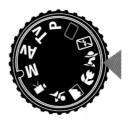

Manual Mode

If you put your camera on manual mode, you're on your own. This mode allows you to select the various settings yourself. Once you feel confident as a photographer or want to experiment with a particular kind of shot, put it on manual and shoot away.

Video Mode

Many newer DSLRs have a video or movie mode, which allows you to shoot videos with your camera. In this mode, your DSLR becomes a video camera and records as simply as if it were taking a still picture. Depending on the size of the digital card in your camera, you can record videos from 10 to 30 minutes or more.

CHOOSING FILE FORMATS

In digital photography, file formats are what store the digital files of the images you've shot with your camera. These files are then uploaded to a computer for either printing or enhancement. There are four main types of file formats: JPEG, RAW, DNG, and TIFF.

JPEG

JPEG is by far the most popular and universally used imaging file format in the world. Digital cameras and camera phones use this format for image capture, and it's the go-to format for sharing digital photos online via websites and emails. JPEGs are compatible with all photo printers and can be displayed on computer monitors and television sets.

WATCH

When shooting in the JPEG format, always set the image size on the largest file size you have available and the quality setting on fine (or super-fine in some cameras).

DNG

Developed by Adobe and supported by all Adobe photo-manipulation software, the DNG file format is an open, raw image format that also provides a free DNG utility converter. The format was created in order to store image data in a generic, highly compatible format. Because of this, many people prefer DNG files, feeling they have a way to save their files that won't become obsolete when they buy a new camera. Because DNG files are smaller than RAW files, you'll have 15 to 20 percent more space to store your images.

RAW

RAW files contain the maximum bit depth the camera can record, so no data is lost. A camera shooting RAW files can record at least three times more digital information than one shooting JPEGs, which means you'll have a much greater ability to make adjustments in the brightness, contrast, and color levels before processing the files. RAW files also enable you to correct errors in exposure in a number of ways so you can make the image look exactly like the scene you photographed. Because adjustments are done on a computer, you now have the kind of processing power that even the best cameras cannot provide.

One important thing to watch for when using RAW files is that the format for each different brand of camera is not the same and can even vary from model to model of the same brand. So if you choose to shoot RAW files, you must be sure the conversion software and image-editing application you have will support the images coming out of your camera. Cameras today that support the RAW file format come with a disk that allows you to convert RAW files to JPEGs or TIFFs.

TIFF

The TIFF is becoming increasingly rare. Some cameras today don't even have TIFF as an option, though you can convert RAW files to TIFF via software. TIFFs contain all the pixel information that makes up an image, giving you more editing flexibility than JPEGs. They can also be read and manipulated by most editing software programs and printed on nearly every type of printer.

However, TIFFs also contain certain adjustments that will occur in the image processing system within the camera (those that have the TIFF option) or in the editing software you really don't need. If they aren't overridden, they can compromise picture quality.

File Format Pros and Cons

Format	Pros	Cons
JPEG	It is the most popular and universally used imaging format. It is the easiest file to share photos online and in emails. Nearly every software application can handle images in JPEG.	When it's compressed by the camera microprocessor, some image data is lost. Lost data can't be recovered.
RAW	It records the maximum bit depth a camera can record. No data is lost. It gives you a greater ability to make adjustments to your images. You can correct exposure errors in a number of different ways.	RAW file formats are not the same for every camera, even those of the same brand. You may need conversion software and an image-editing application for image support. You need a disk to convert RAW files to JPEG or TIFF.
DNG	It works with all Adobe photo-manipulation software, such as Photoshop and Lightroom. RAW files converted to DNG will work with any software that can read the format. Changes to images can be written directly into the file.	The conversion from RAW to DNG can take extra time in the import process. Because all changes are written into the file, you have to back up the entire file every time you make a change.
TIFF	It is a highly compatible format. It contains all the pixel information that makes up the image. It gives you more editing flexibility than JPEGs. It can be read and manipulated by almost every photo-editing program.	The file is very large and can't be used in web-based programs. If it isn't overridden, it can compromise picture quality.

MENUS, HISTOGRAMS, AND INFO BUTTONS

Your DSLR camera allows you to set a number of modes and functions by simply pressing the menu button on the back of the camera and proceeding from there. On your camera, you cannot only correct exposure issues using histograms, you also have access to a number of info buttons that can help you capture a great image.

Operating the Menu

Using the menu on most DSLRs is relatively easy and similar on most brands of cameras. The controls may differ slightly, but they all operate in a similar fashion when you're selecting, setting, or changing menu items. The menu button calls up a screen on the monitor where you can select the specific menu you want from a series of tabs. You then simply scroll down to highlight the menu item and dial in the setting you want. A *set* button allows you to save your selection, and that selection becomes part of the camera's settings until you change it.

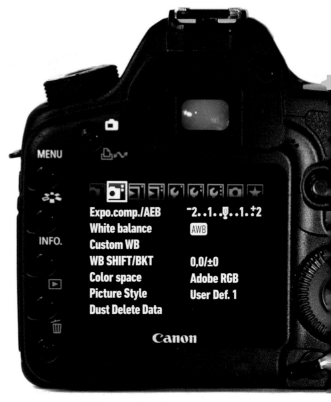

HOT TIP

Take the time to familiarize yourself with the various menu screens. Once you do, you'll realize how much control you have over your camera and how easy it is to operate.

Histograms

A histogram is a graph that visually represents the light and dark elements in a photograph. By looking at a histogram on your LCD monitor, you can quickly determine whether your photo is being exposed correctly. This allows you to correct any slight exposure problems that could make your image less than perfect.

Reading a Histogram

On a histogram, the dark pixels are typically on the left side, while the light pixels on the right side. The peaks in the histogram show you if a photo is predominantly dark, light, or somewhere in between. If your photo has many shadows and dark areas, the peak of the histogram will be skewed to the left side of the graph; conversely, if your photo contains mostly bright areas, the peak will be toward the right side. An even, balanced photo without overly bright spots or dark shadows will have a standard bell curve, with the peak right in the middle, or smaller peaks across the latitude of the screen. As a rule, you want the histogram to show a full, dynamic range with the tones pretty much evenly distributed and not running off either edge or peaking too high.

Setting Up the Histogram

Your camera should already be set so your image shows up on the LCD monitor as soon as you snap it. To show the histogram with your image, call up your menu, scroll down until you reach the histogram setting, and hit the *set* button. That will turn on the histogram that shows the light and dark spots in your image. You also have the option of selecting the RGB histogram setting, which has three graphs showing the red, green, and blue color saturation and gradation in your image. Once you have a good understanding of the color palette in your pictures, you can use the RGB histogram by itself. But to start out, use the dark-and-light histogram to help you learn about your images' exposure readings.

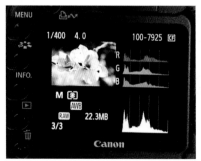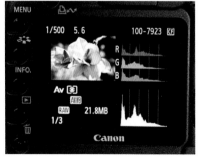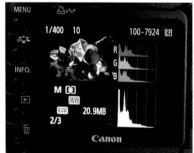

A camera with the RGB histogram setting turned on. The image on the left is a balanced photo, with the histogram peaking in the center. With less light, though, the histogram shifts more to the left, as you can see in the images in the center and on the right.

Info Buttons

The DSLR, like other advanced cameras, has more buttons and other controls than simple point-and-shoot models. Most of these buttons have been created to help you quickly find the certain popular features on the camera. The following are the most common info buttons you'll find on most DSLRs. Because not all camera brands have the same layout, check your manual to see exactly where they are located.

Menu Button

This allows you to access the camera's numerous menus. It can be indicated by the word *menu* or sometimes by a lined paper icon on or near the button.

Frame Advance Button

This button indicates the setting you have chosen for the speed in which the camera takes pictures, in frames per second. Depending on the camera model you have, you can shoot quick sequences at four to five frames per second or slow it down to take a single shot each time you depress the button.

Exposure Compensation Button

Usually marked with a + and - sign, this is used to manually compensate the exposure for a photo when the camera is in an automated setting.

Lens-Release Button

This button is typically located just to the right of the lens mount and usually has no markings. Press and hold it before releasing the lens from the camera body.

Self-Timer Button

This button helps you shoot a delayed photo; you can set the delay time in one of the menu call-ups. It's marked with what appears to be a stopwatch.

Delete Button

This can delete one or multiple photos and is marked with a trashcan icon.

Playback Button

This button can be used to view your stored photos. It has a *play* icon similar to what you find on a DVD player.

ISO

This button lets you see the setting you have chosen for your ISO rating.

Depth of Field Preview Button

This button can help with photo composition. To use it, set the aperture to f/16 or f/22, even if neither of those will be your final f-stop. This feature will then add more darkness to dark areas of your photo while leaving the brighter areas still pretty light. It also eliminates detail and lets you see forms and shapes, which you can then arrange in way you want. This feature works best on photos with a lot of light and shadow.

White Balance

This allows you to quickly set or change your white balance without having to go through the trouble of calling up the menu on the rear monitor.

UNDERSTANDING THE LCD MONITOR

The LCD monitor screen on today's DSLR cameras is an extremely useful feature. Because you have the flexibility to make changes on the spot, the monitor can be a great help in maximizing the outcome of your images.

Today's midrange and high-end DSLRs come with an LCD monitor that's 2½ inches or larger to make viewing easier. The most obvious and pragmatic feature of the LCD monitor is it lets you view an image immediately after you shoot it. But it also gives you a complete readout menu panel to toggle through so you can review and adjust all the camera's features right from the screen.

The following are some of the things you can do via the LCD monitor's menu panel:

- Make adjustments to the shutter speed, aperture, ISO settings, exposure compensation, and metering functions

- Select the mode you want

- Check your battery level

- See how many photos you have saved on your camera

Before you begin shooting, go to the LCD monitor to set all of your features and dialog settings. From there, call up the menu screen in order to set the menu functions; clean the sensor; and set up the contrast, brightness, and density of your images. You can also reformat your digital card and even override the factory settings in the custom functions area.

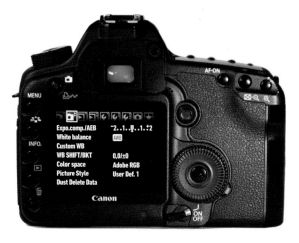

The left image shows what a typical screen looks like and the selections you can make, such as custom white balance settings. The right image shows a photo in the viewfinder with the settings applied.

Once you've captured an image, you can check the monitor to judge both the composition and exposure of the photo. Many monitors now have the option of zooming in on a portion of your image or panning to different areas so you can check the focus on certain parts of the image. If you're not satisfied with what you see, you can make adjustments and try again.

But don't just depend on the LCD monitor to tell you how to adjust for every photo using trial and error. Make sure you still acquire the technical knowledge to make the proper adjustments to your camera on your own. You can always check your results on the monitor, but you should still know how to set the camera yourself.

That said, the LCD monitor is another piece of modern digital photography that can help make your job easier.

WATCH

Some LCD monitors don't perform well in bright sunlight, making it difficult to view images. If your monitor is difficult to see, you can simply turn away from the sun and view the images in the shadow of your body. Another option is to purchase a viewing loupe that fits over the monitor and shades it better in all forms of light.

SETTING WHITE BALANCE

White balance refers to the color temperature (calculated in degrees Kelvin) of light and the effects it has on your image. Even if the setting looks "normal" to your eye, because different sources of light have different color temperatures, your images may come out with a certain hue to them. By selecting the appropriate white balance setting to match your situation, you can achieve perfection in the color tones of your final image.

Automatic White Balance

DSLR cameras come with an auto white balance setting (AWB) that's preset and built into the camera's menu. With this setting, the camera interprets the color cast of the most dominant light source of an image and makes the necessary corrections—so if there's a white object in the image, it should come out properly white. But no camera is perfect; when set to AWB, the camera is taking its best guess when setting the white balance, so there will be times when it's unable to figure out the correct balance. Because of this, some cameras have additional white balance presets, as well as technology that allows you to set the white balance just the way you want it.

The Presets

Preset	Light Source
Sunny, direct sun, or bright sun	Bright sunlight
Cloudy or overcast	No sun; provides slight blue tint to light source to warm color balance
Shade	Bluer than the cloudy preset; warms the balance to a greater degree
Tungsten or incandescent	Conventional light bulb; balances image with a much cooler (more blue) tone than normal
Fluorescent	Fluorescent light

Custom White Balance

To set your white balance manually, you need to show your camera what white looks like in a shot so it can have a reference point for this and the other colors. To tell your camera exactly what the color temperature is, use this little trick:

1. Get a white piece of paper large enough to fill the entire frame of the camera.

2. Set the camera to custom white balance. Focus on the paper under the same light that will be on the subject of your photo, and snap a picture of it.

3. When you return to the custom balance setting, the camera will ask you which image you want to use as your white balance. Select the image of the white paper; the camera will accurately set the white balance for the photo you are about to shoot.

The downside to this process is if you're shooting several photos with different lighting for each, you would have to photograph the white paper before every shot so the camera can readjust. Otherwise, the camera will keep your initial white balance setting, which may not be the best one for subsequent photos.

Setting a custom white balance.

WATCH

For those of you with a high-end DSLR, you might find a white balance setting noted by the letter K. This stands for *degrees Kelvin,* which is how the color temperature of light is measured. Any number below 5000 K is a cooler tone, meaning it shifts to more of a blue cast. Conversely, when the number is above 5000 K, the tone becomes more warm or yellow.

Becoming More Creative with White Balance

Once you're comfortable with your white balance settings, you can try some new things. If you decide to add more of a red or blue cast to your photo instead of lessening it—something that will add more warmth—set the white balance to a more cool setting, which will be shade, cloudy, daylight, or flash. Conversely, if you want to add coolness to an image, simply use a warm white balance setting, such as tungsten or fluorescent. This takes practice and experimentation, but it can certainly make you a more creative photographer.

HOT TIP

If you happen to be shooting in the RAW file format and forget to adjust the white balance to your desired setting, don't worry; the RAW format allows you to make precise white balance adjustments as you process your images on the computer. However, if you are shooting strictly in JPEG format, you won't be able to make the same postprocessing adjustments, so you should take the time to set your white balance properly upfront.

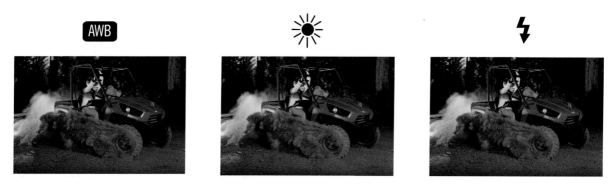

The same photo taken with a white balance setting of (from left to right) auto, daylight, flash, fluorescent, shade, and tungsten.

DSLR cameras use the primary colors red, green, and blue to capture the colors of whatever subject you're shooting. In photography, this is referred to as *RGB,* with red or warm colors at one end of the spectrum, blue or cool colors at the opposite end of the spectrum, and green or neutral in the middle. Each of these has a range of tones that the camera's sensor will capture. However, because the sensor can't filter out the light hitting an object, the camera doesn't always capture the true color of an object unless the white balance is set to make the correct adjustment. That's why learning how to set the white balance is so important.

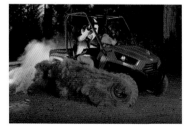

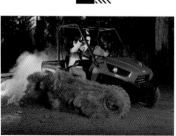

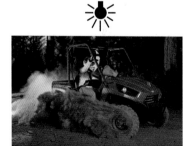

METERING

Metering modes measure the amount of brightness on the subject or an entire scene and set the exposure accordingly. There are three main types of metering modes to which you can set your camera: matrix metering, center-weighted metering, and spot metering. You should know the function of each, because if you set the metering mode incorrectly, you won't get the image you want. So let's take a look at all three and see just how you use each one.

Matrix Metering

Matrix metering—sometimes called pattern or evaluative on some camera models—is in some ways the most complex metering setting. However, this mode is believed to offer the best exposure palette for the majority of photos. Matrix metering divides a scene into small zones (or *grids*) in a matrix and measures each of these grids individually so the camera can get a reading for each section of the frame. The camera then evaluates these readings and produces an average metering for the entire scene. After that evaluation, matrix metering sets the exposure automatically, accounting for both the light and dark portions of the screen.

Best Use	Watch For
Matrix metering works well for subjects that are evenly backlit, such as landscapes and group portraits. It's also the safest mode to use if you aren't sure which one to choose, which is why it's normally the default setting on cameras. For the most part, matrix metering also chooses the correct exposure for your shot.	Matrix metering may not be the best choice for images under strong light with many shadows because parts of the image may wind up either over- or underexposed. Matrix metering also isn't the best setting when you need to meter a small subject.

⦿ Center-Weighted Metering

Center-weighted metering is the default option for cameras that have just a single metering mode. It gives the most attention to the center area of the frame—about 70 percent of the metering takes place around the center of the viewfinder. Center-weighted metering also averages the exposure for an entire scene.

⬝ Spot Metering

Because it only covers 5 percent of the viewfinder and is the smallest metering mode, spot metering gives you the most control over measuring light. And by ignoring the remainder of the frame, it allows you to bring out the most detail in your photo.

Best Use	Watch For
Center-weighted metering is the best mode for photographing people or subjects in the center of a scene, such as a city skyline or a landscape, because it puts the emphasis on the subject instead of the background area. That's also why it's a good mode for shooting portraits.	Center-weighted metering shouldn't be used if the subject of your image isn't in the center of the frame.

Best Use	Watch For
When shooting a portrait, spot metering allows you to meter the light reflecting off a subject's face. It's also the mode to use for macro and still-life photos due to its ability to meter small objects. In addition, spot metering is helpful for photos that are brightly backlit, as it will allow you to avoid silhouetting the subject.	Spot metering can be time consuming, requiring you to be very careful and patient if you want the ideal shot. Because of this, it has limited use for new and amateur photographers and is more often used for specialty photography.

UNDERSTANDING LENSES

There's a consensus among professional photographers that the lens, not the camera body, is the most important factor for producing great photos. They're very selective about their "glass" and always obtain the best-quality lenses they can. So if you're looking to shoot outstanding photos, you should always buy the best lens you can afford. To do that, you first have to know what each lens is used for and which are the most important to have as your skill level increases.

Types of Lenses and Their Uses

Before you go out and buy a bunch of lenses, let's look at the different kinds of lenses you should have as you broaden your photographic horizons.

Prime or fixed lens: This type of lens is perfect for taking portraits and usually gives the photographer faster or wider apertures. These lenses don't zoom or change in focal length and are usually very sharp, though they are smaller than others in both weight and size. Prime lenses can be of various focal lengths—the most common are between 35mm and 80mm—and are relatively inexpensive compared to other lens types. A 50mm prime lens allows the camera to shoot a scene very close to the way the human eye sees it.

> ### HOT TIP
>
> You can also acquire some specialty lenses, such as the fish-eye and ultra wide-angle zoom, once you become more experienced. However, you probably won't use them too much.

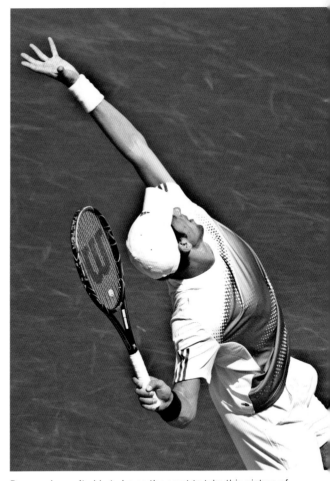

Because I wasn't able to be on the court to take this picture of the tennis player, I used a super-telephoto lens. This gave me a clear picture and made it appear I was shooting close-up.

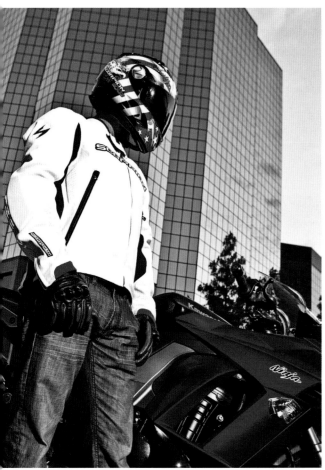

This photo of a biker was taken with a wide-angle lens so I could capture the building, which made for an impressive backdrop.

Zoom lens: This type of lens is probably the best lens for beginning and amateur photographers. These lenses have the ability to shoot at a variety of focal lengths, and the focal length can be changed simply by twisting or rotating the lens barrel. Zoom lenses are available in a variety of focal lengths. New cameras often come with a standard zoom lens that has a focal length of 18 to 55mm; this is often referred to as a *kit lens* because it's part of the camera "kit" that you buy. You can also find zoom lenses in focal lengths of 170 to 300mm, 24 to 70mm, and 28 to 135mm. Zoom lenses are usually the best choice if you plan to shoot a variety of images and only want to bring a single lens with you.

Telephoto and super-telephoto lens: This type of lens is always used by photographers who want to shoot from long distances and produce images that make it appear they were close to their subjects. Telephoto lenses are usually large and bulky and often have to be steadied by a tripod. Telephoto lenses come in both prime and zoom versions, and have a smaller field of view and less depth of field than both standard and wide-angle lenses. As a rule of thumb, the wider the maximum aperture on a telephoto lens, the more expensive it will be. While it's important to know about them, telephoto lenses are probably not something you will normally need.

Wide-angle lens: This type of lens is very popular with landscape and nature photographers because it presents a wide-angle or maximum view. As a rule, anything wider than 35mm is considered a wide-angle lens. Wide-angle lenses can be fixed or zoom and have short focal lengths. They can capture images that are wider than what's seen by the human eye. The most popular focal lengths are 10 to 20mm, 12 to 24mm, and 11 to 16mm.

Macro lens: This type of more specialized lens is used to take close-up images of small objects, such as flowers or insects. These lenses have a very short depth of field and require a great deal of light to capture sharp details—in fact, some have a focal length of just 1 foot. Macro lenses can magnify things the human eye cannot normally see and don't normally require any adjustments.

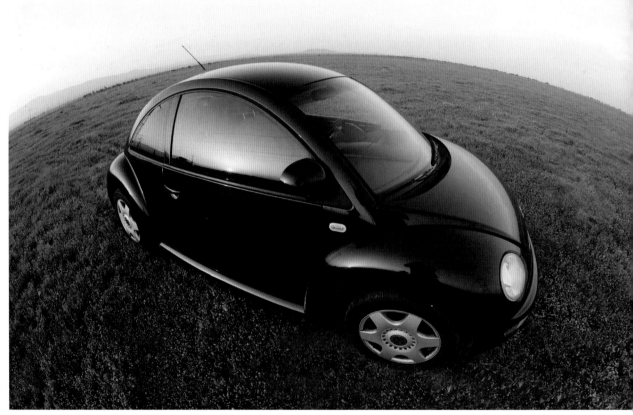

I captured this image of the VW Beetle using a fish-eye lens to ultimately show the radius perspective the lens has on the background.

Using a midrange zoom lens to shoot portraits offers a greater flexibility than a nonzoom. It allows me to stay in one general spot when shooting but change my perspective by a simple zoom in or out.

Purchasing Lenses

Your camera lens is the window to your photographic world, so you should buy the best "window" you can afford. Here are some tips you can use when picking out lenses:

- With lenses, don't go "cheap." There's a big difference in quality between an inexpensive lens and a high-end lens. If you want a high-end lens but can't spend a lot of money on one, look into buying a previously owned lens. Many photographers are looking to change or upgrade their lenses and will offer their old ones for a good price. If you know what you want and come across a lens in excellent condition, you can find some real bargains.

- As you're just learning photography, you should buy the same brand of lens as your camera—that way, you'll be assured it will mount onto the camera body. However, third-party manufacturers make lenses that are compatible with all the major camera brands. Once you feel comfortable branching out, check into them.

- In years past, a prime or fixed lens usually came with a new camera kit. Now, many come with a relatively inexpensive zoom lens, which allows the price to remain reasonable while giving you the versatility you wouldn't have had with a fixed lens.

- Some high-end DSLRs are sold as a camera body only, without a lens. If you're buying this kind of camera, you should already have a number of lenses ready to go or be willing to purchase high-end lenses separately.

UNDERSTANDING AND CHOOSING LIGHTING

Lighting is everything in photography. With the absence of light, a recorded image becomes nonexistent. Fortunately, you can find forms of lighting—both natural and artificial—everywhere. It can be anything from the flash on your camera, to a candle on a table, to a lamp on the side of the bed, to the sun itself. All of this light is available to you, and it's up to you to use it to your advantage and create the image you envision.

Lighting Technical Terms

Before I jump into talking about lighting, I want to share a couple technical terms with you that come up quite a lot:

- **Joule or watt-second:** A joule is a unit of energy or a measured amount of heat being expended. In photography, it's how film, or a digital camera sensor, reacts to the radiation in light. Exposures are measured by the temperature of the light. Like a joule, a watt-second is a derived unit of measured energy, but it's used to differentiate and measure a strobe's lighting output.

- **Guide number:** This term relates to the output or power of a flash unit mounted on a camera (not an external strobe). The higher the guide number, the more light your camera's flash can put out.

Lighting as a Foundation

Professional photographers are constantly studying all types of lighting. It's lighting that creates the mood, helps tell the story, and assists in creating the nuances and subtleties of your work.

Lighting is at the core of every image you create. That doesn't mean lenses and other photographic tools aren't important. But your lighting setup will be the foundation of the image you create and will dictate the quality of that final image, regardless of the camera or lens you use.

Choosing the Proper Lighting

In order to create that foundation, you must know how to choose and use the proper lighting. Let's look at a few primary lighting types and the basic ways you can to use them. With this knowledge, you'll be in a better position to make the right lighting decision in any situation.

Flash Units

Flash units are small, compact units either permanently or temporarily attached to the camera that can provide anything from a big "pop" to a little "spritz" of light. They're easy to use, and you can adjust the settings pretty simply.

You can illuminate the entire frame with an on-camera flash, but I often use the unit to add a little fill light to my subject. One of the downfalls to on-camera flashes is that they're a source of light directly over the lens, so they have a tendency to "flatten" the depth of an image. However, some of today's flash units come with built-in slave units that allow you to have your flash atop your camera and then multiple others set up remotely without wires—this extra light in different areas helps correct the depth problem.

Flash units are pretty handy to have and use and are an inexpensive way to go when building your lighting kit. The power output of flash units is measured by a guide number, and they're typically powered by a couple AA batteries.

This image was taken using an external flash unit like the one see below.

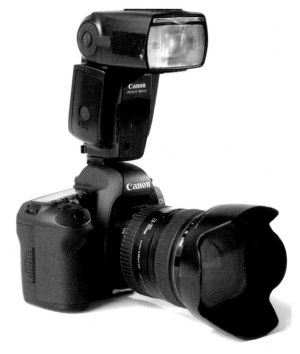

Strobe Units

Strobes are larger, off-camera light sources connected to power packs that maintain a consistency in flash duration and light output. This gives you the security of knowing the flash will have the same output each time it fires, which is important when your lighting needs to be exact each and every time.

Strobe units are much more powerful than on-camera flash units and give the photographer more flexibility when setting up because they can use multiple heads and multiple power packs simultaneously. The output of strobe units is measured in joules or watt-seconds, and their power range can be anywhere from 500 Ws to more than 5000 Ws.

This image was taken using a strobe unit.

Hot Lights

Also called *continuous lights,* hot lights stay on all the time and literally become hot to the touch (hence the name). The yellow "shop light" you probably have out in your garage? That's a great example of a hot light. (Believe it or not, I have a few shop lights in my studio and have even used them on some shoots.)

Some photographers opt to use hot lights because it's easier to see the results of their lighting before they shoot—with strobe lights, for example, the results can only be seen once the image is exposed. However, hot lights offer far less output power than strobe units.

Though the lighting temperature needs to be balanced, hot lights can be used as a viable source of lighting. Numerous types of photographic hot lights are available on the market that range in power from 250 W to 25000 W, with an equally wide variation in price. Look around to see what fits your needs and budget.

This image was taken using a continuous light.

Fluorescent Lights

Fluorescent lights are great for lighting portraits and are used when you're looking for soft lighting to set a tone or mood to your picture. The same kind of strip bank lights you can find in a storage area or garage, these lights typically emit a much cooler tone of lighting and are cool to the touch.

Fluorescent lights are don't have a great deal of output power, so they can't be relied upon to offer much "pop," if that's what you're looking for. However, fluorescent units are available for both photography and videography with interchangeable bulbs that offer color-balanced results and don't emit that typical blue, cyan, or orange tint when used. Fluorescent lights come in multiple sizes, lengths, and number of bulbs.

Tungsten Lights

This is type of incandescent lighting uses a bulb with a filament made from the metal tungsten. Before strobe units, tungsten lights were essential to photographers. Today, many video projects and even television shows use tungsten lights as their primary lighting source. Most tungsten lights are now a form of tungsten halogen lights, which offer the photographer a longer bulb life and longer output consistency.

This image was taken using a tungsten light.

> ### WATCH
>
> Because tungsten lights burn hotter than other types of bulbs, make sure the stands they're mounted on are absolutely safe and stable to prevent injury or fire. If you're moving the lights stands or the bulbs, turn off and unplug the lights from the outlets first.

Natural Light

No mystery here—I'm talking about natural light from the sun. Knowing how to use natural light to your advantage is key to image making. It can be used in many different ways, and each will yield a different look and feel. You can see how the sun can be used purposefully by checking out the photographs that appear in Parts 2 and 3 of this book.

Ambient Light

This is a term used to describe any available lighting source—it could be a reading lamp beside a couch, the sun on a cloud-free or cloudy day, or the natural light coming through a window.

Combining ambient light with other light sources is key to really making a quality image stand out. First, you have to have a thorough understanding of how all types of lighting work and affect the photograph you're shooting. You can then add various types of lighting to an ambient light source and create a one-of-a-kind image.

Once you're familiar with the use of both natural and artificial light sources, you'll be on your way to becoming a more complete and versatile photographer. Knowing how to use all the lighting tools and techniques at your disposal will help you control and shape your work's style and look.

This image was taken using natural light.

LIGHTING TECHNIQUES

In the previous sections, you learned about the various types of lighting and how to choose the correct combinations that will work best under certain conditions. Here, I expand upon that information with some lighting technique terminology you should know, accompanied by images that illustrate them and diagrams that show you how they were set up.

Remember, how you use light will ultimately determine the quality of your images. So explore and be adventurous with lighting. Try a variety of combinations—don't be concerned with making mistakes. That's the only way you'll learn and ultimately master these lighting techniques.

HOT TIP

After you learn about all your lighting options, the real test of your artistic abilities will be in the way you combine various lighting techniques in one photo. Once you can do that with confidence and vision, you'll be able to create the image you want—not just rely on your camera to do it for you.

Back or Side Lighting

Just what their names imply—lighting that's behind or beside the subject. Backlighting creates an interesting separation or depth element to an image, while side lighting is often used to create or add a particular mood to an image.

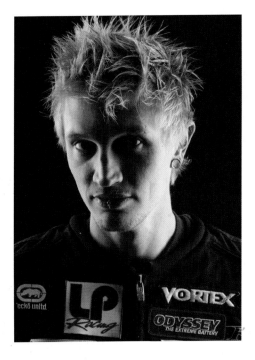

The side lighting for this image creates interesting lights and shadows on the man's face.

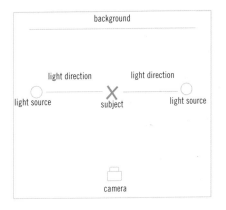

Spotlighting

Lighting that illuminates a specific spot on the subject or within your frame.

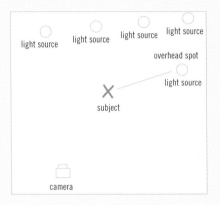

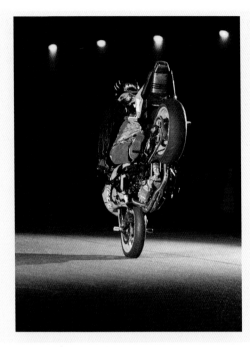

The spotlighting used for this shot really makes the motorcycle pop.

Soft Light

Lighting that's softened by an added element, such as a softbox affixed over your light source or a semi-transparent piece of fabric (known as a shoot-through). The softbox or shoot-through is set up between your light and the subject being lit.

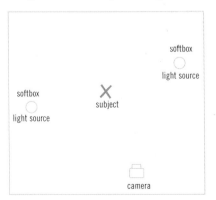

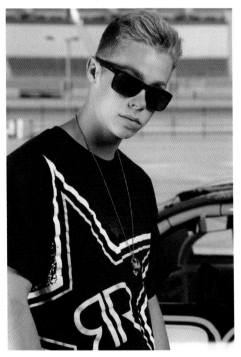

Soft lighting can reduce any skin imperfections and soften harsh lines while casting a warm glow over the entire image, as you can see in this portrait.

Ambient Light

Any source of available lighting in a scene. This can be anything from an area of open shade to the available light in a kitchen.

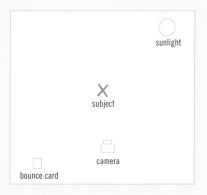

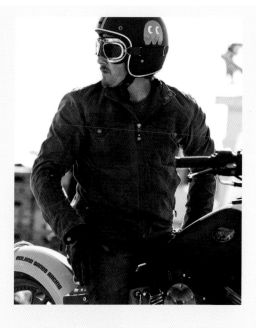

In this image, ambient light is used to silhouette the man sitting on his motorcycle.

Bounce Light

Any source of lighting that you intentionally bounce off a panel, wall, or reflector in some variety of color and/or material. This process creates a softer lighting that can also soften the shadows on your subject.

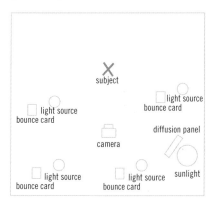

The bounce lighting for this image of the motorcycle on a hillside lends a warmth to the scene.

Hard Light

A direct open bulb or light source that falls unimpeded on your subject. Depending on the distance your subject is from a background, hard lighting can create a very distinct shadow just behind it.

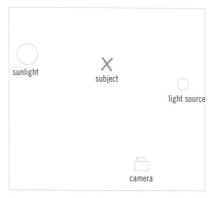

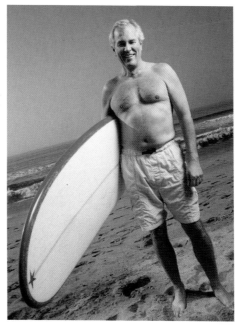

In this image, the hard lighting mimics the sun beating down on the man holding the surfboard.

Ring Light

Either a series of lights in a circular fashion or a flash unit attached around the front of your camera lens in the shape of a circular ring that can smooth or flatten the shadow detail on the subject. It's also great for shooting small or reflective objects.

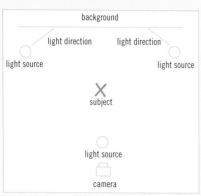

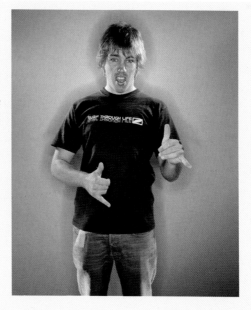

The ring lighting in this portrait creates an interesting halo effect around the man.

LIGHT-SHAPING TOOLS

Now that you have a basic understanding of lighting, it's time for you to move past the ambient light and flash unit atop your camera and become even more creative with your lighting techniques. Besides using a variety of flash units, strobes, and other lights, you can also shape your lighting myriad ways. Here, I discuss some light-shaping tools photographers use in their quest for the perfect image.

Shaping Your Lighting

The following are devices you can use to shape your lighting:

- **Softbox:** A softbox is basically a box with opaque side panels and a translucent front panel that attaches to your light source and diffuses, or softens, your lighting. In turn, it softens the look and feel of the entire image by also softening the shadows. Softboxes come in a variety of shapes and sizes—they can be as small as a shoebox or as large as a tractor trailer, with square, rectangular, round, or dome shapes.

- **Head reflector:** This attaches to the front of a strobe unit and can be used in conjunction with other attachments to help shape light. The circular size of head reflectors can range from 5 to 9 inches, with diameters as large as 11, 14, and 22 inches.

A softbox can help you produce even, soft lighting.

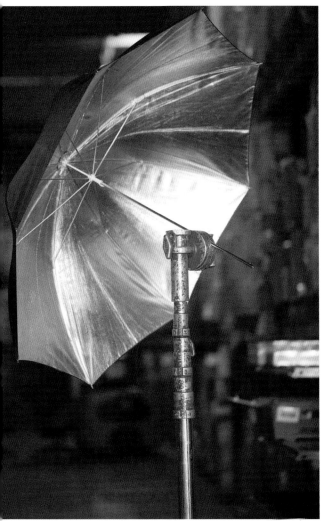

An umbrella softens a light source by either directing light through it or bouncing light off of it.

- **Umbrella:** This tool looks and opens like a standard umbrella and offers a range of colored reflective materials, such as silver and gold. Umbrellas are even available in a white, transparent version that acts as a light diffusion panel or softbox.

- **Barn door:** This item can be attached to the head reflector and helps you control the width and height of the displacement of your lighting pattern. You can also use these—or just the head reflectors alone—to hold specific filters or gels that change the color of your light. Barn doors come in either two-door or four-door attachments and fit nearly every size of head reflector on the market.

- **Snoot:** A snoot is a tool that can be attached to a strobe unit's head reflector and can redirect light into a spot pattern. Snoots are typically used to create a crown or halo light on a subject or to throw a spot of light on a specific area, such as the background on a portrait.

- **Grid:** This honeycomb-looking tool attaches directly to the front of your strobe's head reflector and both reduces and shapes your light. Grids come in a variety of diameters and angles—typically, photographers use grids with angles of 10, 20, 30, and 40 degrees.

- **Beauty dish:** This large circular dish attaches to the front of your light source in place of the head reflector. Beauty dishes are diffused with a variety of different reflective and softening materials either over their entire front side or by a small cylinder in their center that covers the exposed bulb.

HOT TIP

When shooting small objects, such as shiny or reflective jewelry, you can use light-reduction materials altered with the size in mind—for example, small black cards can be cut to the size and shape required. You can also use small mirrors, white cards, silver cards, matte cinefoil, and anything else you can find that will make your lighting more creative for these objects.

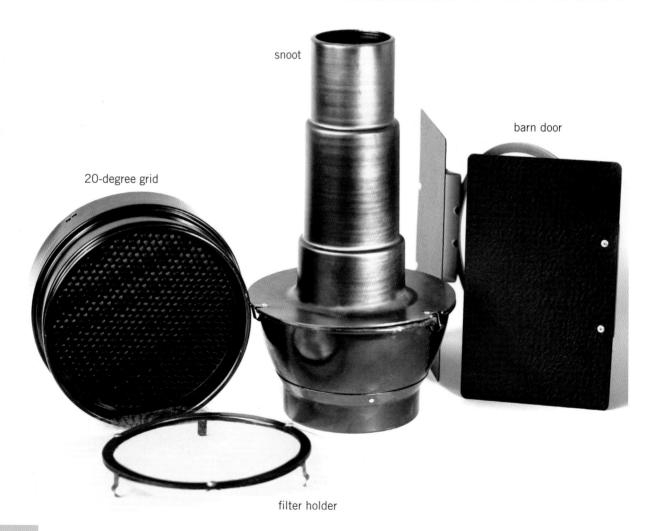

snoot

barn door

20-degree grid

filter holder

Experimenting with Light-Shaping Tools

When it comes to setting the mood for a photo, light-shaping tools can provide a great boost to your creativity. Experiment with the tools I mentioned, and write down what you use for certain shots in a diary or log book. That way, you can revisit what you've done and re-create a shoot the same way, or perhaps try something different. The possibilities are endless.

Lighting and how you use it to capture the shot you want is vital to photography. I could easily write an entire book on lighting alone, incorporating all the tricks and techniques I've learned and used over the years. But with the basics I've provided, you can build your lighting kit slowly, picking and choosing what you like. You'll be surprised at how quickly you begin to see a difference in your images.

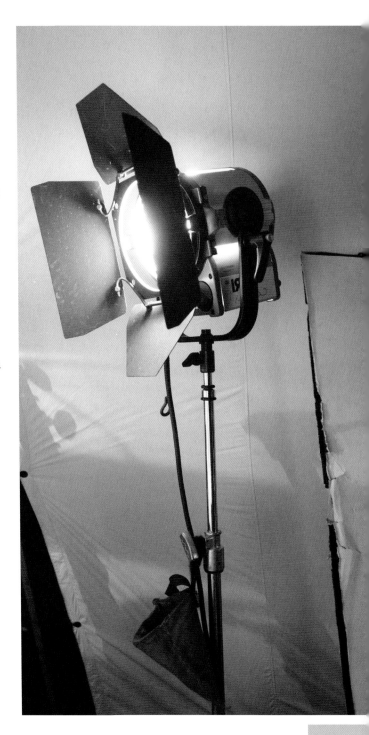

MEMORY CARDS

Memory or media cards give you the means to store images in your camera and transfer them to your computer for review. Some cameras can support several different types of cards—they either have multiple card slots or provide different format choices. Memory cards function on what's called *flash memory,* which means no power is needed to store recorded data. Today, even standard cards can record literally thousands of print-quality images for you, and new research and development is constantly producing memory cards with increased storage capacity and better performance at lower prices.

What About Speed?

When deciding on the kind of card you want to purchase, you should know the way they measure speed. The speed at which various cards function can vary. Some simply have speeds measured in megabytes per second (MB/s). Others, however, have an *x* suffix attached to them, such as a 1000x speed. The x measurements are based on a CD player's data transfer speed, which is 150 kB/s or .15 MB/s. So if a device says it transfers data at 10x, in theory it should move data at 1.5 MB/s.

Some SD media formats use a Speed Class rating. The number used relates directly to the minimum transfer speed of the card—thus, a Class 2 card has a minimum transfer rate of 2 MB/s.

The Main Types of Memory Cards

Here are the main types of memory cards you may want to consider for your camera:

- **SD (Secure Digital):** SD cards are widely used today to record both images and movies. They're small—about the size of a postage stamp—and relatively inexpensive. The newer SDHC (Secure Digital High Capacity) cards are the same size but offer high-capacity storage, from 4 GB to 32 GB, with an increase in speed and performance. They cost more than SD cards, of course, and may not work in your camera; if you decide to look into SDHC cards, be sure your camera can accept them.

- **CF (CompactFlash):** Though SD formats dominate low- and midrange cameras, CF memory cards are supported by higher-end cameras the pros use. CF cards are larger and stronger than SD cards and hold up better in adverse conditions, such as extreme cold and heat. There are Type I and Type II CF cards, the only difference being that Type II cards are slightly thicker. The majority of cameras support both types, though some recent camera models have dropped support for Type II cards.

- **SDXC (Secure Digital eXtended Capacity):**
SDXC cards are the latest in SD media, with a
storage capacity of 32 GB and 64 GB. These are
used most often for shooting high-definition
video, which is becoming more popular with
DSLR users. The prices of SDXC cards are still
high and not that many cameras accept them;
however, both price and compatibility are
expected to change over the next several years.

- **UDMA (Ultra Direct Memory):** UDMA cards
have higher transfer rates to and from the card.
Most cameras that support CF storage will also
support UDMA technology. However, only
UDMA card readers are able to support the faster
transfer rates these cards offer.

Buying a Memory Card

The following are some helpful things to keep in
mind when looking for a memory card:

- Decide how much memory you need. Most
applications, especially for beginners, only
warrant a 4 GB or 8 GB card. You might only
consider a larger card if you plan on shooting
high-def video or a big event.

- Look for a card that offers a warranty with
technical support. Some of these warranties cover
the life of the card.

- Buy a card that includes image-recovery software.
This gives you a way of recovering any images
that have been deleted accidentally.

- You can find the best prices for memory cards at
online stores.

Various types of memory cards. Here, you can see examples of
CF, UDMA, and SDHC cards.

- While it's not difficult to connect your camera to
your computer in order to transfer images from a
memory card, it may be worthwhile to purchase a
memory card reader to save on the battery life of
your camera. Memory card readers are relatively
inexpensive and can read several different cards at
one time via the USB port on your computer.

WATCH

Never remove a memory card while images are
being recorded. Some cameras have a small light
that will tell you if the card is still in use. If you
have one of these, wait until it shows you it's fin-
ished, and then safely turn off your camera before
removing the card.

OTHER EQUIPMENT

One thing you've probably realized by now is that it takes a great deal of equipment to create quality photos. You need a tool, a lens, a light, and so on for almost everything. As you begin building a supply of equipment to have both at home and on the road at various photo shoots, you need to make sure you have the following:

Camera Bags

The temptation may be to think any old bag will do, but a camera bag is actually a very important piece of gear—you don't want to show up to a shoot with a tiny shoulder bag and limited equipment. You can find camera bags of various shapes and sizes; pick whatever will best suit you and your needs. For example, I have waist bags and backpacks for smaller shoots and medium and large bags with more storage space for gear and accessories for bigger shoots.

If you ever need to carry several bags or can't carry a heavy bag on your back, you can opt to have a rolling Tenba bag, which is designed specifically for photographic equipment. These well-built bags are perfect for traveling on location and keeping all of your gear safe.

A full equipped camera bag keeps everything organized.

Light Stands

As you build your personal lighting kit, you'll need some sturdy light stands to hold your lights. Light stands come in many sizes, heights, and quality. As with any photographic gear or equipment, always buy the best quality you can afford.

WATCH

More often than not, everything will need to be battery operated. Always make sure you have fully charged battery packs, fresh batteries in your camera, and a fully charged computer battery. That way, you'll be able to complete your shoot without saying those dreaded words: "The batteries are dead."

Transport your light stand on location with a portable bag.

HOT TIP

Two pieces of incidental equipment you might consider for your kit are mafer clamps and grip tape. Mafer clamps are strong clamps that can secure items to just about any surface. Grip tape—which comes in black, gray, or white—is a residue-free cloth tape that helps you secure items.

Tripods

When you're shooting certain types of photos where sturdiness is paramount—or if you're using long, heavy lenses that need support—tripods are a must. Tripods come in many sizes and have numerous attachments, so look for ones that fit your style and needs. Make sure you have a tripod that has a locking, quick-release mount on the head. This will allow you to quickly remove and replace the camera without having to undo screws and then tighten them all over again. If you're shooting video with you DSLR, you should also have a tripod with a fluid mount head for smooth tilting and panning.

Backdrops

If you enjoy shooting portraits, you should look into having a series of colored paper or muslin fabric backdrops. Remember, if you decide to acquire backdrops, you also need the proper heavy-duty backdrop stands, a sturdy crossbar on which to hang your backdrop, strong clamps to hold the backdrop on the crossbar, and sandbags to keep everything in place.

Remember, all this equipment isn't for everyone. Once you begin shooting lots of images, you'll have to judge what you need. Just make sure you don't skimp on equipment—quality gear and accessories are vital to you becoming a top-flight photographer.

SETTING UP A HOME STUDIO

If you'd like to have a studio that's readily accessible, you can set up one in your home. Creating a comfortable workspace in your home isn't as difficult as it may seem.

Here's the equipment you need for a home studio setup:

- A backdrop, such as a large piece of paper that's neutral in color or a roll of photo background paper, and a backdrop stand to hold it in place

- Head extension cables to connect the lights to the power pack

- A light modifier, such as an umbrella

- Lighting, such as a strobe, and a light stand

- A power pack to charge and fire your lights

- Sandbags to hold the stands in place

- A snoot to control the direction of the lighting

When setting up a home studio, your primary concern should be safety. Are there cords laying around that someone could accidentally trip over? Is it possible that a light stand or backdrop could fall over and hurt you or someone else? Whether it's taped down or weighted with sandbags, your equipment should always be secure to avoid injury. Also, make sure your home has enough electrical power to support your lighting setup. Some of your lighting necessities could strain or overload your electrical system, leading to potential shock and fire hazards.

When it comes to lighting, you should find a room large enough for your lighting equipment but deep enough to use an 85mm portrait lens. Typically, you'd like to set up in a room where you can close out all the light so you don't have any unwanted shadows or light streaks. Does your home have an area with tall-enough ceilings to accommodate light stands with lights and softboxes on them? If not, you'll have to improvise the best you can. You may consider using ambient light. As long as you can comfortably place your subject in the basking light coming through a window, you can use it to your advantage.

HOT TIP

With a home studio, you also have the option of setting up shoots in your front or backyard. The key here is to pay attention to how the light falls on to your property throughout the day so you know when the best time is to do a particular shoot. If you live in an apartment, you might consider a local park or nearby grassy area for your outside shots.

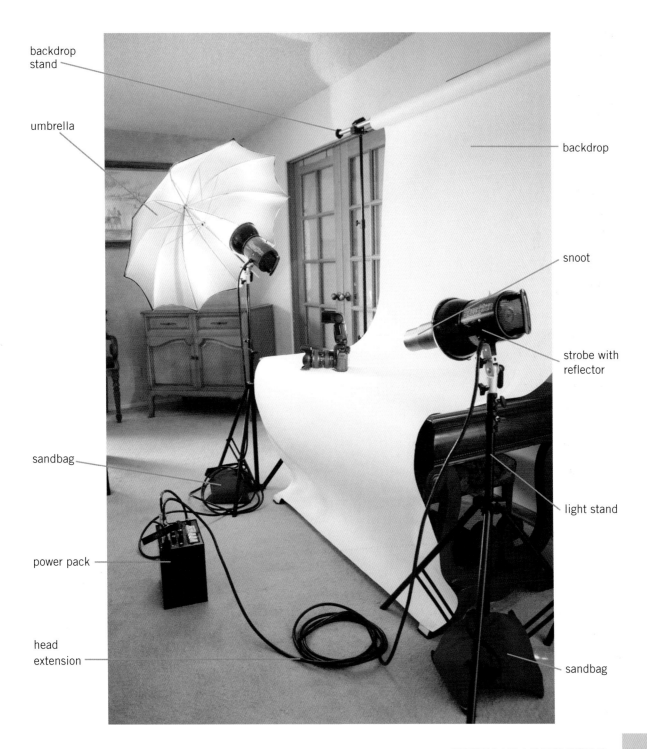

backdrop
stand

umbrella

backdrop

snoot

strobe with
reflector

sandbag

light stand

power pack

head
extension

sandbag

SETTING UP ON LOCATION

Shooting photos isn't limited to your home or personal studio—many times, you'll want or be asked to set up a shoot at a different location. Depending upon the type of shoot you'll be doing on location, the equipment you need to have on hand will vary. Here are some of the basics you should have for a simple location setup, along with some examples of what else you'd take with you on a more complex shoot:

The Basics

- Camera

- Lenses

- Flash

- Small flashlight (to help you find things in the bag)

- Tripod

WATCH

Never leave a light stand with a mounted light free standing! It can be easily knocked over and injure someone. For each light stand you set up, have at least one 10-pound sandbag on the stand to hold it down securely.

More Advanced Extras

- Lighting cases

- Softboxes and stands

- Mobile workstation

Transporting and Caring for Your Equipment

Going on location requires portability for your equipment. To keep your gear safe and free of dirt, you must find the proper mode of transport for it. For smaller location shoots, like a family portrait session in the park, you most likely need only a backpack of gear and a tripod in hand. However, if you're shooting an event that requires a lot more equipment, you don't want to put a heavy pack on your back and then lay everything on the ground. For shoots with more equipment involved, it's a good idea to have a collapsible but sturdy rolling cart that can carry all your gear from your car to where the shoot will occur.

HOT TIP

When shooting on location, it's always better to have more gear than you need—nothing is worse than seeing a great shot and not having the proper equipment to shoot it. The special shots don't come along that often, and if you miss one for lack of a key piece of equipment, you won't forgive yourself. Plan ahead by making a list of the equipment you'll need and getting it packed and organized the night before. That way, you won't forget something in the morning.

Reviewing Your Images

You can always take photos at the location and review the photos on your computer when you're home or at your studio. However, if you'd like to review images in real time, you can take a computer with you. And so you don't have to sit on the ground or in your vehicle to review your images, bring a portable chair or two.

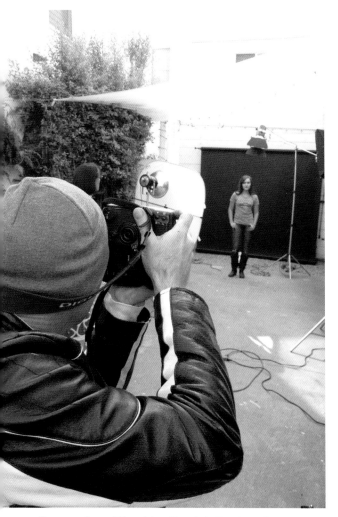

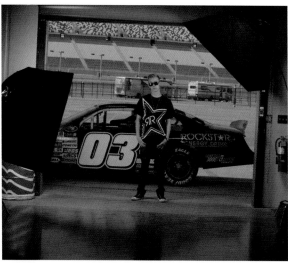

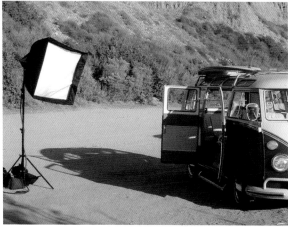

These are from different location shots I've done. As you can see, some location shoots require minimal setup, while others need a lot of equipment to execute.

THE SHOTS

Now that you have a grasp of the basic functions of your DSLR, it's time to see how your camera can be put to use in a variety of photographic situations. First, I discuss some composition basics for your images, including finding your focus, the rule of thirds, shooting vertical versus horizontal, negative space, and diptychs and triptychs.

I then take you on some real photo shoots and visually show you what it's like to photograph subjects ranging in topic from architecture, to weddings, to landscapes, to portraits, to night shots.

For the shots, I both show and explain why a particular shot works and what you have to do to make the most of your subject. For the main examples, I provide information on how to meter the shot; the focus techniques; and the equipment, lens settings, and exposures I used. I also take a look at general focus, composition, and exposure issues that come up with each type of shot.

And to help you capture the best shot, I also give you some shooting tips that apply to the specific genre, as well as some dos and don'ts for quick guidance. In addition, I include a page of inspirational images to encourage your creativity. Finally, I end each topic with a number of shooting suggestions for you to try so you not only come home with some good standard shots, but some special ones as well.

My goal here is to make you a working photographer. You may not be going out on paid photo shoots, but after studying the different shots in this part, you should be able to take your camera anywhere and capture plenty of impressive images.

SEEING YOUR IMAGE FIRST

Many art professors and photographic academics have said that an amateur "takes" a picture while a professional "creates" one.

While a great deal of hard work goes into producing a professional-grade image, there will invariably be a magical moment when the image suddenly comes to you. You may be walking down the street or driving in your car when you see something special. It could be the lighting on someone's face through a window, or a person bathed in warm light like a seventeenth-century painting. Perhaps it's the reflections of a golden sunset off a mirror and onto a vase of flowers, or the manner in which something is composed against its background. When you see it, you'll know it—perfection. And that, in essence, is what I mean by seeing your image.

When someone says, "He has an eye for it" or "A picture is worth a thousand words," that person is referring to seeing the image first. Some people have an intuition or knack for seeing the image and can do it easily. Others have to train themselves to see it. But take heart. You can learn how to see your image over and over, each time you shoot. It comes back to a couple of basic but often difficult fundamentals of photographic picture creation.

No matter the subject, seeing your image simply begins with having an idea of what you want to create. Let's say you want to shoot a portrait of your child. Before you get your child dressed and have her squirming in front of the camera, asking if you're done yet, take a step back and think about what you want to accomplish with the picture. Maybe grab some magazines that feature creative images. It never hurts to have some inspiration.

Once you've found an image that moves you, dissect it from top to bottom—don't just look at how the subject appears in the photo. Look at the background color, density, and tonality. Look at the lighting and how it is sweeping through the frame and over the subject, the way it is structured to fall off the subject and onto the background or on an object alongside the subject. Is it a hard light that is casting deep, dark shadows? Or is it a softer light that is barely illuminating the subject? What props or wardrobe in the photo inspire you? Take in everything about the picture, then do the same thing with dozens of additional pictures until you have a clear, concise idea in your mind of how to create the picture you want.

Make a list of all the things you liked in the images you reviewed. Then, as you think about setting up your shoot, refer back to your list for ideas on how to create the images you envision.

You can use this method with any type of subject or photo shoot you want to do, from portraits to landscapes to candid group shots. Find some inspiration and make a list, and soon it will begin to come naturally.

As I was sitting on the beach during a family trip to Hawaii, I noticed my friend's daughter gearing up for a swim with her mask and snorkel on her head. She was framed perfectly with the beautiful sky and sand around her. It was an image I "saw" first, then set up to capture.

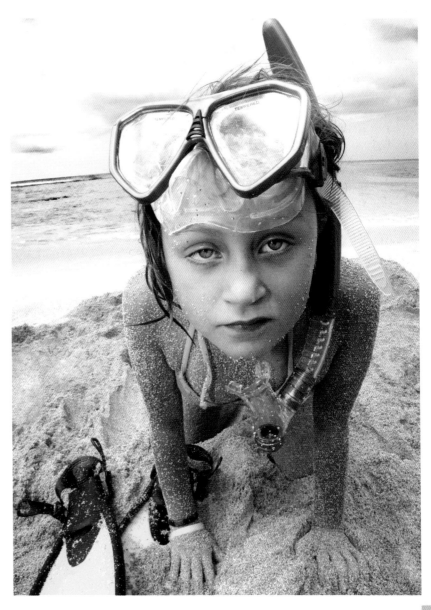

FINDING YOUR FOCUS

As with most pictures you create, finding your focus at the outset will not always come easily, but it won't be the banc of your existence. Finding your focus is a learned skill that involves more than just selecting autofocus, pointing, and shooting away. It will eventually become the signature of your images as you create your own style.

Every picture you create—whether it's beautiful roses on a flowering bush, a car parked atop a picturesque vista, or a family walking down the beach silhouetted in a golden-orange sunset—will require you to think about where you want your focus to begin and end. Do you want a particular part of the frame to be more in focus or completely out of focus? This involves knowing where your focus field lies and commanding it from the moment you set out to create the image.

Remember, a picture isn't only about what's in focus; it's also about what's out of focus.

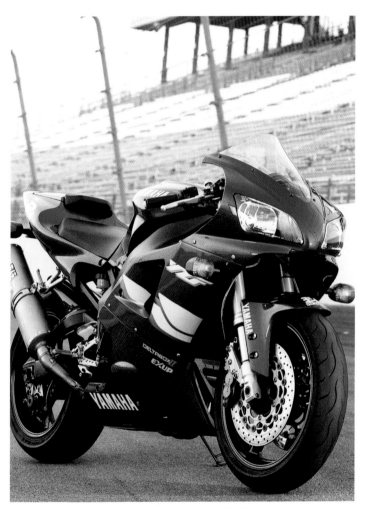

In this portrait of a motorcycle on a racetrack with the grandstands in the background, I wanted to have the beautiful architecture and shape of the motorcycle's front end–faring design be the focal point of the shot. Therefore, I started my focus point just before the front tire, allowing it to softly fade by the rear taillights. By the time my focus dropped off and reached the grandstands, it was slightly soft, which allowed the grandstands to support the overall image as more of shapes and tones than sharply focused parts of the picture.

For this image, I chose to take a photo on the fuller side of the focus field to show how it affects the image. With the cyclist riding through the tranquil trails surrounded by the green and golden foliage along the side of the creek, I wanted the final image to show the overall environment. Therefore, I chose a 28mm lens, set my aperture in the midrange of f11, and pulled my focus to the leading edge of the green bushes on the lower-right side. The result illustrates a greater depth of focus and allows my image to have more of an impact with the surrounding environment.

THE RULE OF THIRDS

The rule of thirds is a design theory or guideline that is primarily based on the study of an image's composition, balance, and overall structure in relation to the final creation of the work.

It was first written about in 1797 by John Thomas Smith in his book, *Remarks on Rural Scenery*. In the book, Smith quoted a 1783 work by Sir Joshua Reynolds that discussed the calculable balance of dark and light in a particular painting. Smith expanded on Reynolds' ideas and wrote about the intersecting lines at play in an image, which he aptly called *the rule of thirds*.

The theory or guideline of the rule of thirds suggests that an image should be divided into nine equal parts by two equally spaced vertical and horizontal lines. The more important features of the picture should then be placed along these lines or the intersections of these lines. The intersections of these vertical and horizontal lines are commonly known as *power points,* but I've also heard them called *crash points* or *slam lines*.

For the image of a racecar driver and his pilot, I positioned the crew chief on the far right third and the driver climbing in the car in the middle third, leaving just the car in the far left third.

Many in the academic or professional photographic field feel that by developing your pictures using the rule of thirds, you add more structure, tension, and, ultimately, interest to the final composition of your photograph.

Does every image you create or shoot need to follow the rule of thirds? No, but it's always good for you to be aware of it. That way, you can put it into practice when you feel confident enough to do so. And who knows? At some point, you may decide to explore a little using it and see what you come up with. The results may surprise you.

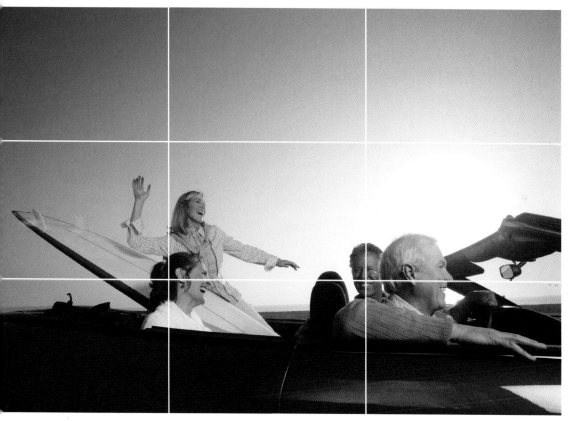

With this image of four adults riding in a convertible, I intentionally positioned them in the lower third of the frame in order to allow plenty of negative space for an editor to write copy or a designer to have room for graphic designs.

SHOOTING VERTICAL VS. HORIZONTAL

Have you ever looked at a picture of a person in the horizontal or landscape format and wondered why the photographer cut the person in half? You probably asked yourself, *Why didn't he just turn the camera 45 degrees and shoot his subject in an elongated format to show the entire body?* Seems simple enough. But believe it or not, many people never even think about turning their camera on its side so it's in the vertical or portrait format.

Most DSLR cameras come with a shutter-release button on the side of the camera as well as on the top. If you haven't checked your camera for that side button, now is a good time.

When deciding whether to shoot in the vertical or horizontal mode, here's a good rule of thumb: Draw an imaginary line around your framed picture, leaving just a little space around the top and bottom edges. If the resulting shape is a horizontal rectangle, shoot in landscape format. However, if the shape is a vertical rectangle, shoot in portrait format.

While this is a very simple trick to help train yourself to see vertical versus horizontal, there will also be times when this formula doesn't hold true and you'll want to switch back to the opposite format.

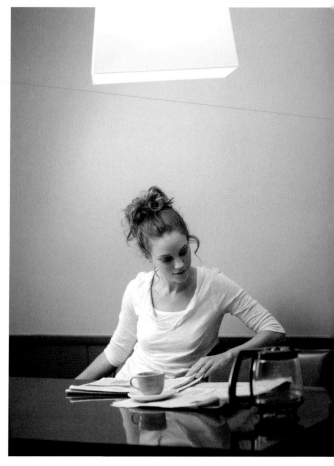

This vertical picture—a warm image of a lady having coffee and reading the morning paper—lends itself nicely to a portrait-style format. There are no empty walls or chairs at the table on either side, so it makes a nice, inviting photograph in this mode.

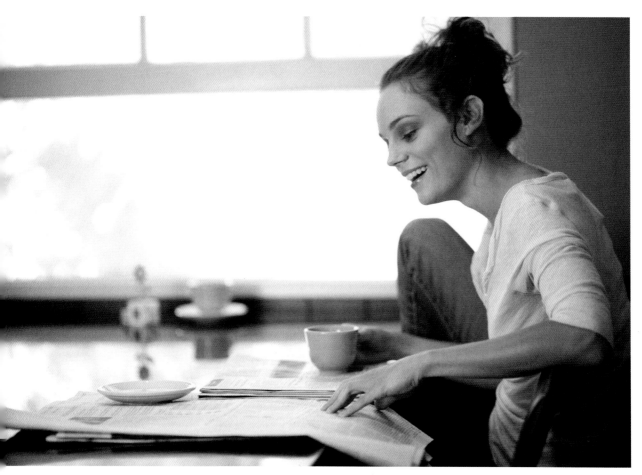

With the horizontal image, the same look and feel applies. Even though the left side of the picture has empty space in it, I wanted to allow the newspaper and the items on the table in the back to have their own space, as they, too, are part of the overall story I'm telling.

NEGATIVE SPACE

There will be times when you're in the process of creating images that something in your pictures seems to be off. It doesn't make sense: you've followed all the written rules of photography and taken advice from creative friends and fellow photographers on lighting, composition of your images, endless lens choices, depth of field selections, shutter speed combinations, and more. Yet something just seems to be missing from your pictures. They're just not having the impact you're hoping to achieve.

In most of my 25-plus years of creating imagery, I've learned that there's an unwritten aesthetic rule to making your photographs stand out and allowing them to truly become your own, showcasing your individual look and sense of style. The concept of negative space can help you out in this regard by adding more interest to your photographs. When I speak of *negative space,* I'm referring to the space around and between the subject of an image. Adding negative space is something I do constantly to many of my photographs. With every shoot, whether it's for professional or personal use, I look to see if shifting my frame slightly or zooming out for more negative space will give my picture more impact.

To try this yourself, take a step back from your shoot, relax, and look at your working process in a way you haven't done before. Think about the visual box you've created in your mind, and have a closer look at how you approach your image-making craft. Do you just grab a camera, put it on the auto feature, and start snapping away at whatever is in front of you? Or are you meticulous and overly structured in your approach? Or, like most people, do you fall somewhere in between?

After you've taken that step back, you should have in mind the great image you want to create. You're seeing that image clearly in your mind and know just how you want the point of focus and focus falloff for the picture. You also know what your lighting needs are, so you have a handle on what you want to accomplish with the project.

Now take it up a notch. Whether you're setting up to compose a shot of that superb culinary creation you've just bought at the local pastry café or creating a personal portrait of someone, look very closely at your frame and see if you can add some negative space to the left or right or the top or bottom of the frame. Will that space breathe more life into the scene and bring an essence to the story that wasn't there before?

This is the general concept of negative space, and while it can play a significant role in image creation, sometimes it's simply a tool you can use to give an image a new look and feel.

By adding negative space to my photograph of the young lady on the sailboat, the picture went from being something you might see in a clothing catalogue to a picture that tells me more about the beautiful wooden boat and would look more at home in a fashion or lifestyle magazine. Adding negative space to this image is one of the moments where more is better than less.

DIPTYCHS AND TRIPTYCHS

While *diptych* and *triptych* are ancient Greek terms that have been used for centuries to describe art, they are used today in digital photography to refer to how one might assemble an image or a collection of images for display. Once brought together, it becomes a cohesive story made up of two (diptych) or three (triptych) separate pieces of one image or a series of images from the same shoot. Compiling images in this manner can be a great way to show your work.

The best part about creating diptychs and triptychs is simply being able to display your work in a fun manner outside of just having a single picture hang in a frame on your wall. It's creative and interesting, as well as a good conversation piece.

To make a diptych or triptych, start by figuring out the overall size you want your combined image to be. Then, depending on whether you're making a diptych or triptych, crop the image in half or in thirds vertically. Save each separate piece as its own file, then print it as a standalone picture.

Just remember to save each of the pieces as a separate file—*do not* save as your original file.

And you don't have to stop at diptychs and triptychs. If you really want to have some fun with a series of photographs from a recent shoot, try creating a four-piece tetratych, a five-piece pentaptych, a six-piece hexaptypch, a seven-piece heptaptych, or even an eight-piece octaptych.

ARCHITECTURE

Creating stunning architectural images takes vision, a bit of patience, and a sense of design. But don't think you're limited to shooting the grandest architecture; you can obtain stunning results from even the most mundane objects. Your subject could be an old-world castle on top of a hill in a European countryside, an impressive concert hall (like you see here), or a lamppost at the end of a street.

EQUIPMENT
LENS: 16–35mm f2.8L II USM **TRIPOD:** None **LIGHT:** Natural ambience

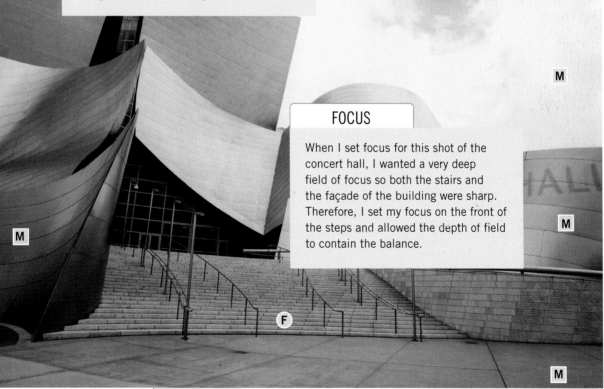

METER

When I metered for this shot of the Walt Disney Concert Hall's main entrance, I took into consideration the white-gray clouds with the small blue patch of sky and the structure itself, which is numerous angles and shapes made from reflective metals. To get my desired look, I used a combination of aperture and shutter-speed settings along with neutral density filters.

M

WATCH

The lighting and how it strikes your subject is key in shooting quality architectural photographs. The shadows from the light source are what create depth, contrast, texture, and even unique reflections. The effects from the lighting combine to showcase your vision of the finished image.

M

M

FOCUS

When I set focus for this shot of the concert hall, I wanted a very deep field of focus so both the stairs and the façade of the building were sharp. Therefore, I set my focus on the front of the steps and allowed the depth of field to contain the balance.

M

M

M

M

F

| 20mm | 1/60s | f16.0 | ISO 100 |

GET IT RIGHT

Architectural photography is really about having an eye for lines, structure, texture, and design. If you compose it properly, an architectural image can truly show the structure in the way the creator or designer meant it to be seen. When shooting architectural photography, wide-angle lenses are often the preferred choice, as they have a wider field of view. But take caution: these lenses can also contort and bend the subject in your frame.

EXPOSURE

Exposing the reflective building and the trees and bushes with the illuminated lampost was tricky. But by taking precise metering readings of each, I created a properly exposed and appealing image.

COMPOSITION

I always try to show something different about architecture that others might miss. In this image, I took into account shadows, spines, and other details that make this structure look otherworldly.

FOCUS

Focus can truly elevate a seemingly mundane shot. In this image, I set my focus on the nearest green foliage so everything—not just the building—was shown in a tack-sharp manner.

DO

Be patient and look for new angles and points of view that everyone else may just walk past.

Use wide-angle lenses that show the entire frame and allow for greater depth of field.

DON'T

Don't artificially tilt your camera to create off angles.

Try not to shoot outdoors in the middle of the day when the sun is directly overhead.

TRY THIS!

An archway or pillar of an architectural building • Tombstones or headstones at a cemetery • Old wooden farmhouses or barns in the countryside • Shoot up from the ground or down from a rooftop • Structures in varying stages of construction • Shoot in black and white using dark red filters • Old, historical buildings in your area

AUTOMOBILES AND MOTORCYCLES

Every so often I'll travel to remarkable locations that just lend themselves perfectly to a photo shoot without the need for much setup. This canyon location has the kind of sweeping S-turns and challenging hairpin turns that bring out local motorcycle riders in droves. On this particular corner, I wanted to be sure to incorporate the incredible mountain views into my shot. The same principles apply whether shooting cars or motorcycles.

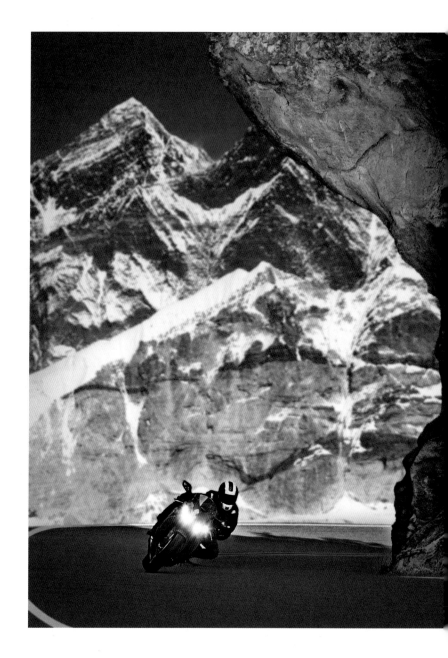

EQUIPMENT
LENS: 70–200mm f2.8 lens (shot at 148mm) **TRIPOD:** None **LIGHT:** Natural

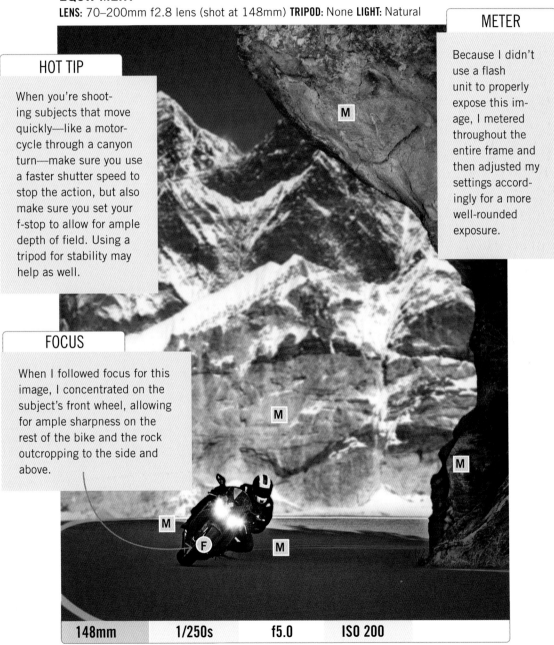

METER
Because I didn't use a flash unit to properly expose this image, I metered throughout the entire frame and then adjusted my settings accordingly for a more well-rounded exposure.

HOT TIP
When you're shooting subjects that move quickly—like a motorcycle through a canyon turn—make sure you use a faster shutter speed to stop the action, but also make sure you set your f-stop to allow for ample depth of field. Using a tripod for stability may help as well.

FOCUS
When I followed focus for this image, I concentrated on the subject's front wheel, allowing for ample sharpness on the rest of the bike and the rock outcropping to the side and above.

148mm	1/250s	f5.0	ISO 200

GET IT RIGHT

When shooting near a rock (as I have here) or on dark pavement, remember that both surfaces will act as a source of reflection and automatically add darker shadows to your subject. If it's a bright day with the sun overhead, be cautious to not overexpose your subject or the background if one or the other is in the shadows.

EXPOSURE

Underexposing your image when shooting action can be frustrating because the opportunity for the same shot may not come again. In this image, the underexposed frame not only changes the look of the subject, but also makes the entire environment appear dull.

COMPOSITION

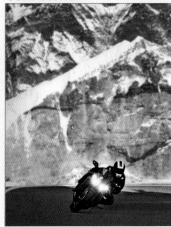

When composing your frame, you're telling a story about not only the subject, but also the location and the beauty of the area. With this picture, the cropping is too tight and too close to the subject; it doesn't show the rock outcropping of the canyon's wall on the right side of the frame.

FOCUS

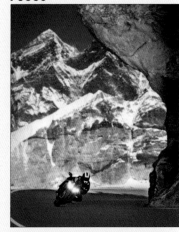

When shooting a fast-moving subject coming toward your camera, setting your autofocus icon in the lower third of the frame lets you stay composed shot and keeps the subject in sharp focus. Here, the image is out of focus due to improperly setting the auto-focus feature too close to the camera.

DO

Use a faster shutter speed, and potentially an elevated ISO setting, to get a larger field of focus.

Meter the entire frame for the best exposure. Remember to expose for clear details in the shadow areas.

DON'T

Try not to shoot in too much dappled or mixed lighting. It will create horrible highlights and shadows.

When shooting fast-moving subjects, avoid getting too close when using a wide-angle lens.

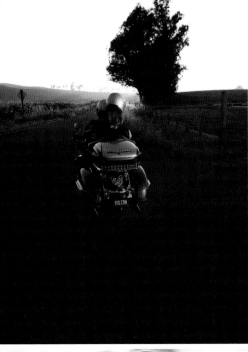

GET CREATIVE

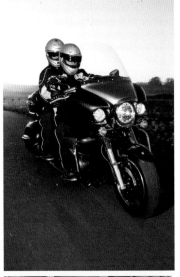

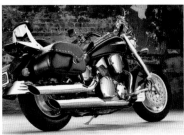

TRY THIS!

Shoot with a long lens to compress the action against the background • Add a flash unit or multiple flash units to add light to the shadow areas • A beauty shot that shows the best features of the vehicle • Pan with the subject with a slower shutter speed to create a motion blur effect • Shoot from atop a ladder or an elevated position • Sunset on a winding country road

FAMILY AND KIDS

Shooting pictures of a family with children can be fun and adventurous if you allow everything to unfold naturally. It can also be one of the most difficult shoots to do well, because people's insecurities can come out when they're in front of a camera. I've found it best to allow the pictures to come to me with very little direction. When shooting the picture of this mother with her son, I allowed them the freedom to be themselves—to smile and laugh—so I could capture them in their world, not mine.

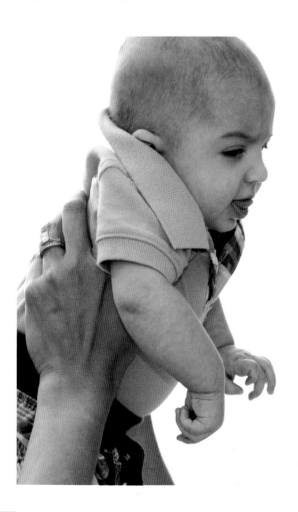
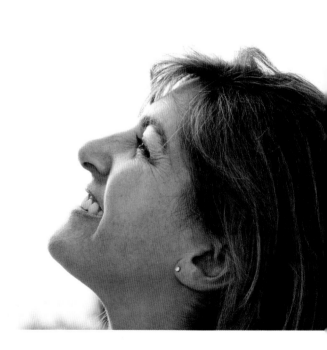

SET IT UP

EQUIPMENT
LENS: 85mm f1.2 **TRIPOD:** None **LIGHT:** Natural

WATCH

When shooting families or kids, try setting your camera's exposure and shutter speed in advance so you can just watch and allow the photos to happen as they normally would. If you take a fly-on-the-wall approach, you will get some great documentary-style pictures.

METER

When I was metering the photograph of the mother with her son, I considered the skin tones of both and then the color and tone of the mother's hair. I allowed the background to become more high key but mainly focused my attention on the subjects.

FOCUS

When setting my focus for this image, I concentrated on the mother's face and her son. Shooting with an 85mm lens allowed me to have the falloff of the focus be just a few feet past them.

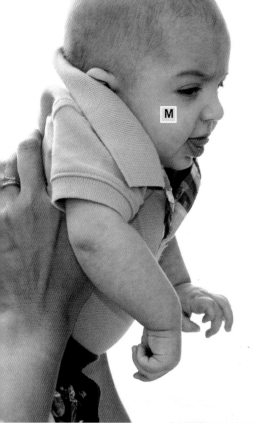
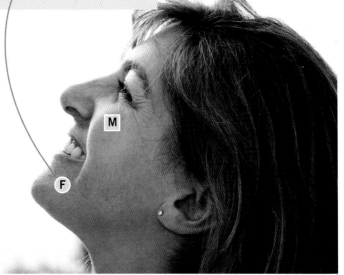

| 85mm | 1/200s | f8.0 | ISO 100 |

GET IT RIGHT

Younger children have a limited attention span, and family members never seem to want their pictures taken. With kids, try singing a song or humming a tune they are familiar with, or maybe have a little stuffed animal handy to get them to look toward the camera lens. With older family members, you need to be the director. Be very clear with what you want from them, but have patience with all of their insecurities.

DO

Be aware of what everyone in the picture is doing by keeping both eyes open or looking through the camera as you speak to them.

Always remember to tell your subjects what you want, not what you don't want.

DON'T

Don't get frustrated when a child is not responding to your requests.

Avoid setting up too much equipment before you shoot. Most families become self-conscious when put in front of a variety of lights and tripods.

EXPOSURE

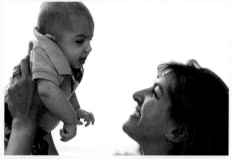

Underexposing your images can be really easy to do when you're caught up in the moment of shooting outdoors, as in this image.

COMPOSITION

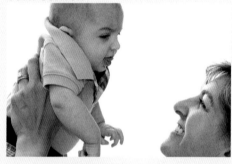

This picture has cropped the mother and the son too tightly, creating an unbalanced feel to the final image.

FOCUS

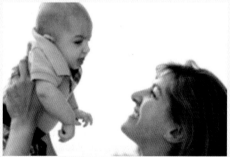

Because it can be difficult to know the right moment during these shoots, the focus here shifted off of the subject and created a soft look and feel.

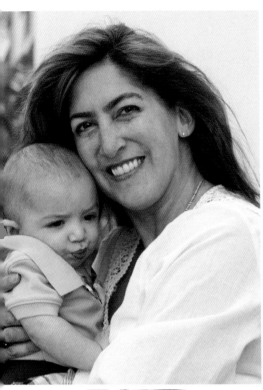

GET CREATIVE

TRY THIS!

Portraits during a time of pregnancy • Have the kids or family riding bikes, riding skateboards, or inline skating • Add chairs or a couch for the family to sit on • At a park, a beach, or other interesting location • Add family pets • Wear a fun hat the kids will want to look at • Individual pictures of each family member • Mount a toy character to the top of your camera

WEDDINGS

Weddings—the gathering of family and friends for the ceremony and the reception afterward—can truly bring out the best in photographers. You have to be incredibly prepared and sense what is going to happen before it actually does. And you have only one chance at grabbing that special and memorable image—there are no do-overs. It's intense. The photograph of this couple walking up the aisle in front of their family and friends immediately after being married speaks volumes about their love and commitment to each other. In the end, that's what a great wedding picture is supposed to do.

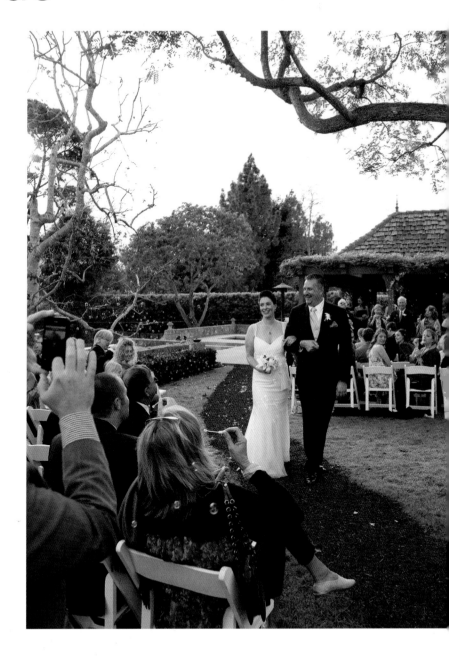

EQUIPMENT
LENS: 28–70mm f2.8 **TRIPOD:** None **LIGHT:** Natural sunlight

HOT TIP

Arrive at the location of the ceremony well ahead of time so you can check out the wedding route and visualize where the couple will walk after their vows. Also take note of the seating arrangements and where potential obstructions may be once the couple begins to walk up the aisle from the altar.

METER

With this particular event being an outdoor ceremony, I metered the area of the grass, the darker color of the aisle, the rooftop in the rear, and the trees in the foreground to get an equal exposure throughout my frame.

FOCUS

Focusing on this image was fairly simple. Shooting in a vertical format, I set my autofocus points to the middle of my frame and kept the couple within my area of focus as I followed them down the aisle.

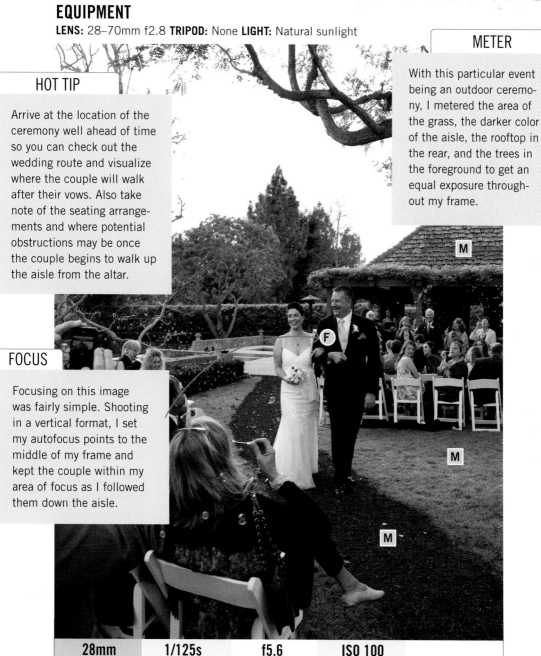

| 28mm | 1/125s | f5.6 | ISO 100 |

GET IT RIGHT

When you've been asked to be the wedding photographer, no matter the size of the event, always remember that this is truly a memorable event for the couple getting married. You've been entrusted to create the memories that they will share for a lifetime. So be completely prepared and confident in the task at hand.

EXPOSURE

With this picture of a beachside ceremony, the image should have been more balanced to illustrate the blue ocean and rolling waves. To accomplish this, the image's background needed to be exposed, then a fill flash should have been added to illuminate the subjects.

COMPOSITION

When you're composing a photo—especially at a wedding—look to create images that tell the various stories of the event. This image of the wedding couple with their cherished friend shows the pure joy and happiness of the moment.

FOCUS

With this portrait of the man, I chose to focus on his face while bringing his unique wedding band into the lower part of the frame. Noting that it was an outdoor ceremony, I wanted the palm trees in the photo as well, but just out of my field of focus.

DO

Be overly prepared with multiple lenses, cameras, and a list of what you are going to shoot.

Have clear conversations with the couple about their expectations and goals for their pictures.

DON'T

Never be too obtrusive or in the middle of the party unless you're shooting a picture.

Try not to stay in one place for too long.

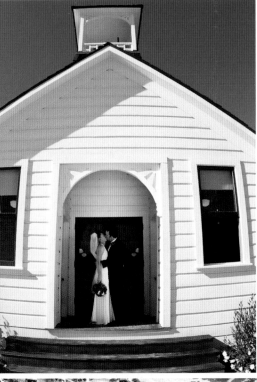

GET CREATIVE

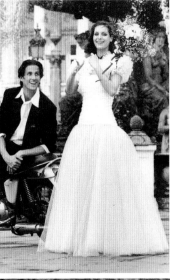

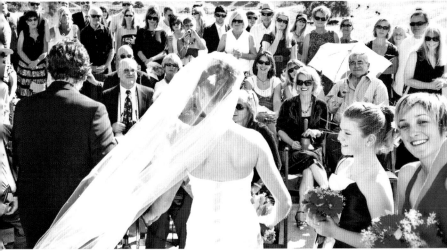

TRY THIS!

Shoot at various heights and angles • Details of the bride's dress or the groom's tuxedo • Shoot in soft or diffused lighting • Shoot lots of people smiling and having fun • Close-ups of the table ornaments • Capture the tearful moments of the family or bride and groom • Create motion blur with your slower shutter speed while people are dancing • Macro details of the flower corsage or the bride's veil

SILHOUETTES

There will be times when you're out shooting that you'll see an image framed against a contrasting background. This kind of image can speak more about the subject than if it were frontlit and colorful. On a recent outing to the beach, I came across this beautiful young lady standing atop a lifeguard tower staring out at the ocean. She was trapped against the radiant yellow sunset and perfectly framed to create a silhouette image, so I grabbed my camera and created this image of her.

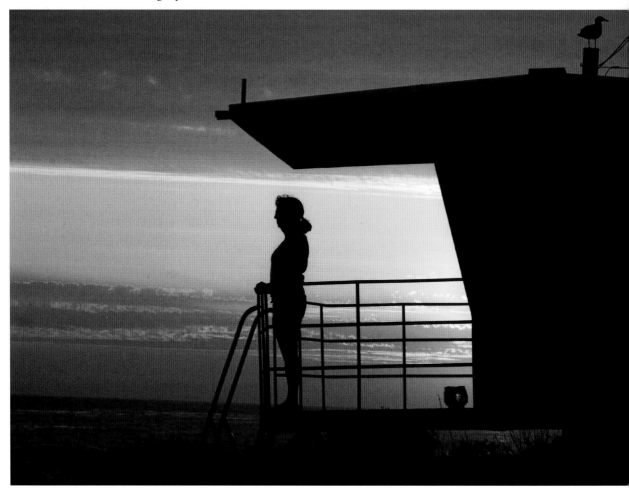

EQUIPMENT
LENS: 28–70mm f2.8 **TRIPOD:** None **LIGHT:** Natural

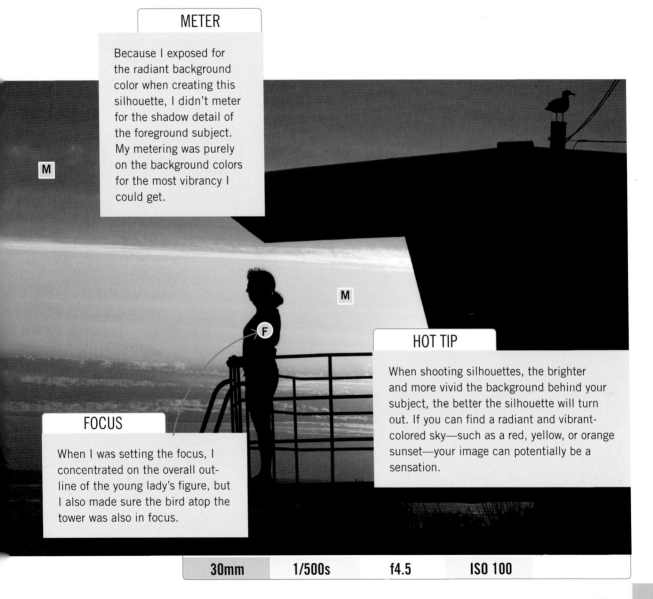

METER

Because I exposed for the radiant background color when creating this silhouette, I didn't meter for the shadow detail of the foreground subject. My metering was purely on the background colors for the most vibrancy I could get.

HOT TIP

When shooting silhouettes, the brighter and more vivid the background behind your subject, the better the silhouette will turn out. If you can find a radiant and vibrant-colored sky—such as a red, yellow, or orange sunset—your image can potentially be a sensation.

FOCUS

When I was setting the focus, I concentrated on the overall out-line of the young lady's figure, but I also made sure the bird atop the tower was also in focus.

| 30mm | 1/500s | f4.5 | ISO 100 |

GET IT RIGHT

Shooting silhouettes can be a blast and add a bit of flair to your photo slideshows. It can be a little daunting and challenging at first, but just make sure you find the right spot to set up beforehand. Finding the best angle and allowing the lighting to work in your favor will also help in creating the best image you can.

DO

Prepare ahead so you're ready to shoot when the light is at the optimum angle for your composition.

Place your subject against a background that creates the best contrast and separation from your foreground.

DON'T

Try not to allow anything in the background to impede the outline of your subject.

Be careful not to look directly into the sun or at your light source as you compose and focus on your subject.

EXPOSURE

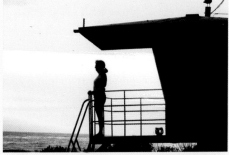

A true black silhouette is what you want to achieve. This overexposed photo changes the true black tone and turns the background a washed-out yellow.

COMPOSITION

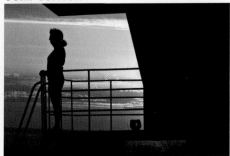

The black tone is what supports the story, but by cropping out part of the tower and roof with the bird on it, the image's story now seems incomplete.

FOCUS

When I was focusing on this image, I used the auto-focus feature on my camera. By doing so, the focus fell off my subject and onto the background of the bright sky.

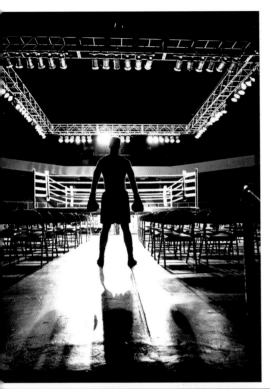

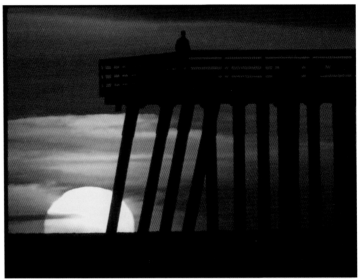

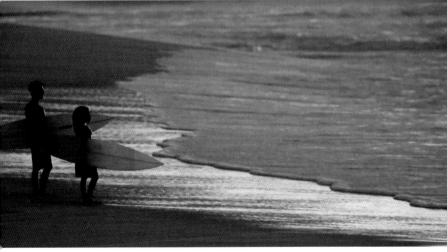

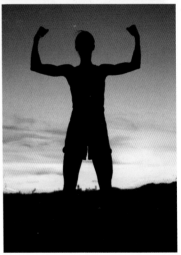

TRY THIS!

Place a light behind your subject to create a brighter background • City skylines • People walking the sandy beaches at sunset • Use colored filters to accentuate the colors in your pictures • At the beginning or end of the day, when the sun is at its lowest • Use slower shutter speeds to create a blurring motion • Your subject against a bright wall • Telephone poles and their lines down a long country road

BACKLIT SUBJECTS

Though at first glance it may look easy, there's more to shooting backlit subjects than meets the eye. The trick is to incorporate the lighting as part of the overall picture. In this image of the fisherman, the shafts of light coming over the ridge of the hilltop add more drama and intensity to the picture than if it were simply a blue sky or a sunset. Shooting backlit subjects requires a keen eye for lighting, and that often means shooting at just the right time of day.

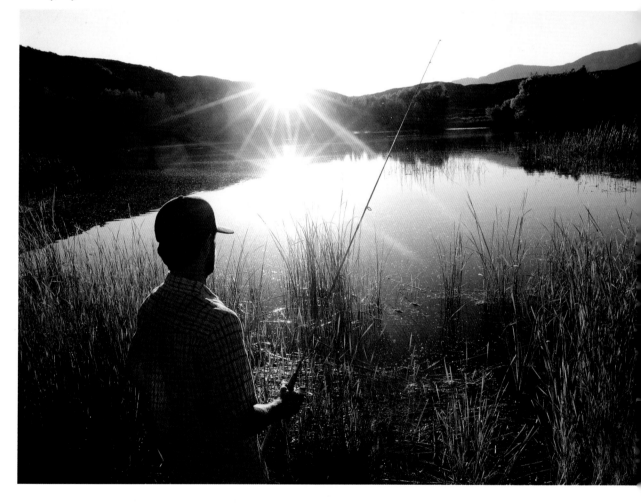

EQUIPMENT
LENS: 24mm f2.8 **TRIPOD:** None **LIGHT:** Natural

METER

When I metered for the exposure on this particular image, I took into consideration the subject fishing, his shirt, the lake with all of the green reeds in the water, and finally the hills in the background.

WATCH

When shooting a backlit picture, try to make the light part of the structure of the shot itself, not just a light coming from the back of the subject. The illumination you get will be much richer, give greater depth to your picture, and showcase your artistic flair.

FOCUS

It was critical to include the lake and its green foliage in my depth of focus on this picture, as it really is the main character in the story I'm telling.

| 24mm | 1/125s | f11.0 | ISO 200 |

GET IT RIGHT

Remember that lighting, regardless of the direction from which it comes, is the key component to creating stunning pictures. While there is no one way to set up your lights when shooting a backlit photo, be sure to move your backlight around in the frame. Also, don't be afraid to allow the backlight to become the dominant source in the photo.

EXPOSURE

By overcompensating the exposure settings for the high-value lighting of this backlit fishing image, the photograph as a whole became too dark to really show the overall beauty of the image.

COMPOSITION

Composing a backlit picture can be a little tricky. Try not to allow the shafts of light to overcome your subject's face; it will create an obscure figure, as you can see in this example.

FOCUS

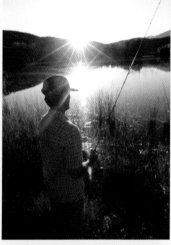

Getting the focus set properly on backlit photos can be difficult, since most of the time the lighting is blaring into your lens. With the fisherman in this photo, the soft focus has taken all details away from him.

DO

Be creative with the direction of the backlight and the placement of your subject.

Meter all points in your frame—highlights as well as shadows—for a more balanced final image.

DON'T

Avoid shooting with too much backlight coming directly into your cameras lens.

Try not to finely focus on your subject as you're facing the backlight.

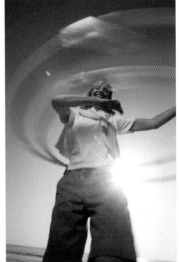

GET CREATIVE

TRY THIS!

Use backlight as a crown light • Action sports • Urban cityscapes • Ocean waves crashing on rocks • Shoot clouds while adding color filters • Wide-angle landscapes • Skiing or snowboarding • Shoot both high and low angles • Portraits • Horseback riding • Trail running

SUNSETS AND SUNRISES

Sunsets and sunrises are by far one of my favorite subjects to shoot. Shooting sunsets or sunrises can render some of the most naturally colorful and striking results in any photograph. If you live near a pier, a bridge, or an interesting set of buildings, try using them in your picture, too. This picture is of the world-famous Malibu Pier, which I try to capture in pictures a few times a year.

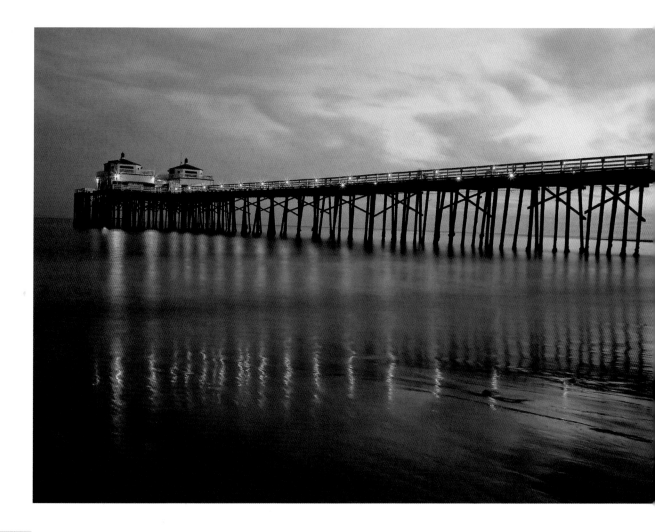

EQUIPMENT
LENS: 20–35mm f2.8 | **TRIPOD:** Gitzo Ocean Series 5 | **LIGHT:** Natural

FOCUS

The focus for this image of the Malibu Pier was set to include the foreground sand just a few feet in front of the camera, as well as the entire length of the pier. Shooting with a wide-angle lens and at a very small aperture assisted in achieving the result I wanted.

HOT TIP

When shooting sunsets, always get to the location about an hour or more before the sun goes down to prepare for your shot. I'll walk the location if I'm unfamiliar with it and then watch to see where the sun is going to set.

METER

Metering for sunsets can range from being fairly simple to very intricate. In this photo, my exposure metering was on the colors of the sky and the water of the ocean in the foreground.

35mm	30s	f19.0	ISO 100

GET IT RIGHT

Believe it or not, many things are going on all at once when you're shooting a sunset or sunrise. Primarily, the sun and its color intensity are changing quickly. But the weather may also cause the sun to not be as vivid. I always scout my locations and do my weather homework ahead of time, so when I arrive to actually shoot, I am prepared with a list of what I want to accomplish.

DO

Try using color-enhancing filters when you're shooting sunsets or sunrises.

Try shooting with extremely long shutter speeds, like 10 or 20 seconds or more.

DON'T

Try not to angle your camera too far down or up when shooting an object in the sunset.

Avoid shooting with too high an ISO number, as it will add unwanted digital noises to the picture.

EXPOSURE

In the example image, the underexposed and darkened sky not only changes the look of the subject, but also darkens the vivid blues, pinks, and oranges too much.

COMPOSITION

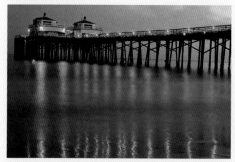

Composing your sunset or sunrise photos will be what makes or breaks your picture. By cropping out a good portion of the pier, someone viewing it wouldn't get what it truly looks like in real life.

FOCUS

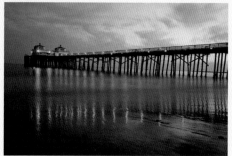

Take caution to make sure your focus is set so that your image, from edge to edge, is in as sharp a focus as you can achieve.

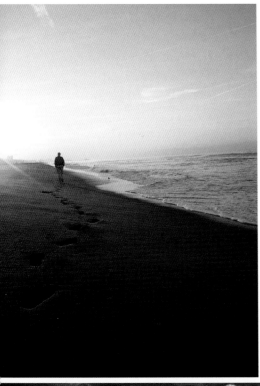

GET CREATIVE

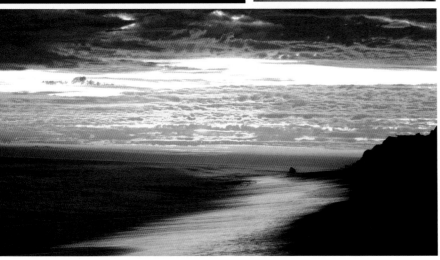

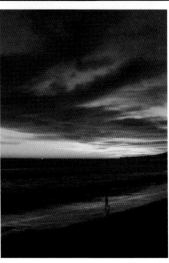

TRY THIS!

Shoot city skylines • Friends at the beach • Walking the sand at sunrise • Use a flash during sunset • Take photos of cars on the freeway • Boats sailing in the harbor • Use your car as a subject • Runners on the boardwalk • Mountain vistas • Sunset on a fall day • Shoot a farm at sunrise

LIFESTYLE

Shooting lifestyle photography can be a great deal of fun because you are typically right in the middle of everything— the good times and the action. It's definitely high up on my list of topics to shoot. However, lifestyle photography can also be a bit tricky. You want the pictures to look natural and real, yet all the while you're putting a camera in someone's face, as I tried to do in this photo of a hiker.

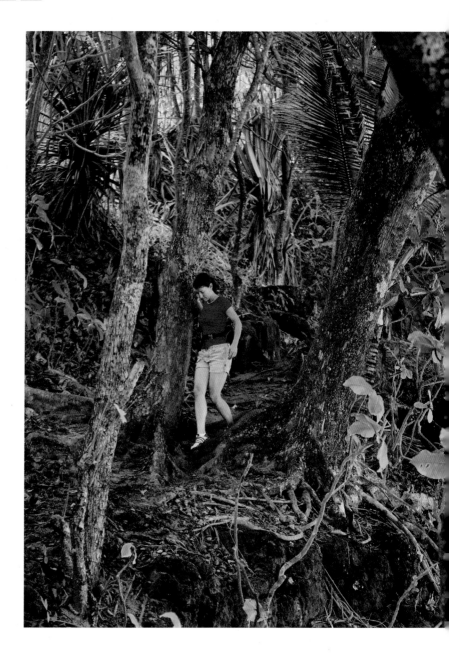

EQUIPMENT
LENS: 70–200mm f2.8 **TRIPOD:** None **LIGHT:** Natural sunlight

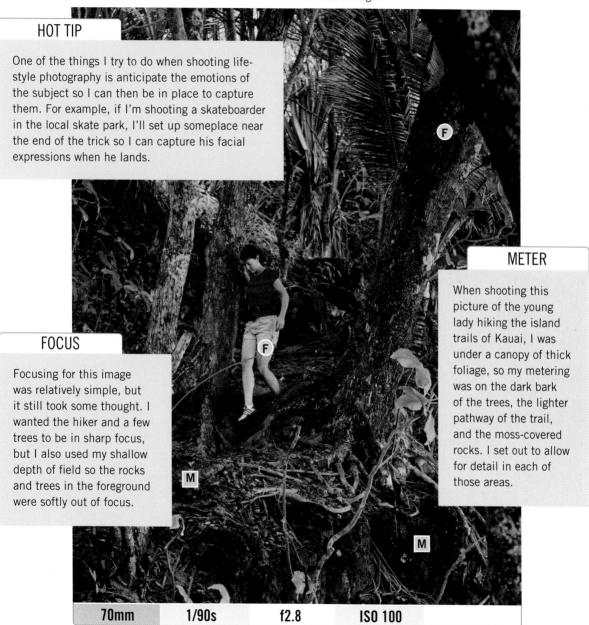

HOT TIP

One of the things I try to do when shooting life-style photography is anticipate the emotions of the subject so I can then be in place to capture them. For example, if I'm shooting a skateboarder in the local skate park, I'll set up someplace near the end of the trick so I can capture his facial expressions when he lands.

FOCUS

Focusing for this image was relatively simple, but it still took some thought. I wanted the hiker and a few trees to be in sharp focus, but I also used my shallow depth of field so the rocks and trees in the foreground were softly out of focus.

METER

When shooting this picture of the young lady hiking the island trails of Kauai, I was under a canopy of thick foliage, so my metering was on the dark bark of the trees, the lighter pathway of the trail, and the moss-covered rocks. I set out to allow for detail in each of those areas.

| 70mm | 1/90s | f2.8 | ISO 100 |

GET IT RIGHT

Shooting lifestyle pictures is about capturing the true essence of what's happening. It can be the moments when people are laughing, the activity taking place, the human emotion, and even the beauty of the location. Just remember: anything can and usually does happen at the drop of a dime. The last thing you should be worrying about is the technical results of your pictures. For this reason, I typically preset my camera's exposure settings so that no matter what's going on, I can concentrate on the creativity of it all.

EXPOSURE

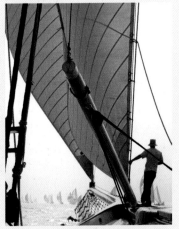

When exposing an image, having the sky overexposed can actually frame your subject better than if it had been a darker blue. You can see the results of this in my picture of the man aboard the sailboat's bow.

COMPOSITION

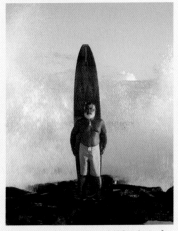

Had I merely composed this shot of the man holding his surfboard without considering the powerful waves crashing on the rocks behind him, this photograph would not have had the same intensity and interest.

FOCUS

Focus can be used as a tool to draw your viewer to certain parts of the frame. In this shot of the young man standing amongst the trees, I used a selective-focusing technique.

DO

Add a flash unit or other source of lighting that will give a little more flare to the picture.

Give your subjects props to help tell the story you're creating.

DON'T

Never overly direct your subjects to the point they become too stiff and tight-looking in the image.

Don't just stand back and let all the fun happen elsewhere—follow the action.

GET CREATIVE

TRY THIS!

Create motion blur with a slow shutter speed • Friends at a café having coffee • Playing a sport at the park with your kids • Your kids or pets playing with their toys in the backyard • Hiking with family or friends • People riding the subway or metro line • Shoot cyclists or runners in urban landscapes

LANDSCAPES

Landscape photography can offer some very challenging yet rewarding opportunities to be creative with your work. During a short period of the year on the West Coast of the United States, there are extreme low ocean tides. On one warm and clear evening, I chose to photograph the Ferris wheel and roller coaster atop the Santa Monica Pier. The combination of the setting, the lights, and the natural colors were too beautiful to resist.

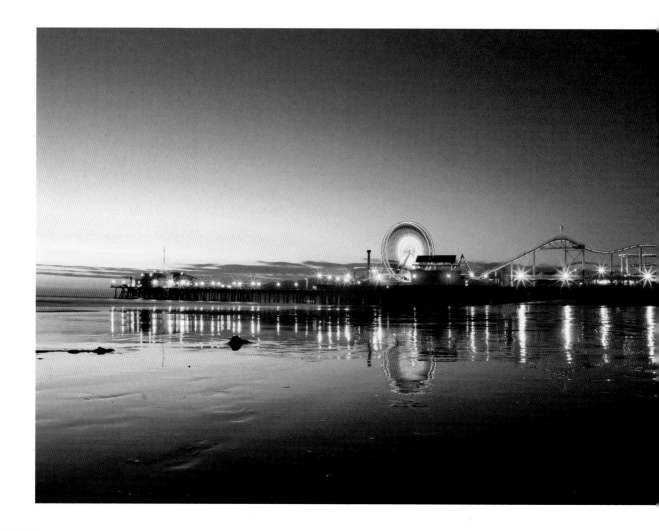

SET IT UP

EQUIPMENT
LENS: 20–35mm f2.8 **TRIPOD:** Gitzo Carbon 3-Section **LIGHT:** Natural

WATCH
When shooting landscape photos in either a vertical or horizontal format, always make sure your horizon line is level when you look through your viewfinder—not tilted or skewed.

METER
When I metered this shot of the pier with the roller coaster, Ferris wheel, and wet sand, I knew I would need to have a long exposure and very small aperture to capture the colors and reflections the way I wanted them.

FOCUS
Focusing on this image of the pier was fairly simple, as I was shooting with a very wide-angle lens. Therefore, I set the focus out about 10 or 12 feet from the film plane and let everything else fall within the extreme field of focus.

| 20mm | 20s | f32.0 | ISO 100 |

GET IT RIGHT

Landscape photography lends itself to capturing special pictures if you maintain your patience. The most challenging aspects are the lighting and how you compose your shot. Pick a time that has warm light or long shadows, since that helps set a mood to the location. Having a quality tripod is also helpful, as you can use a very small aperture and slower shutter speed to give greater depth and intensity to your picture.

DO

When shooting long exposures, always use a tripod and weigh it down with a small sandbag.

Experiment with various lens sizes and aperture settings.

DON'T

Don't shoot in the middle of the day, when the sun is at its highest point in the sky.

Avoid tilting or skewing your horizon lines. The result will appear very unnatural.

EXPOSURE

The longer exposure on landscape photography can really enhance or detract from the image. Here, the picture wasn't exposed long enough, creating an ominous feel.

COMPOSITION

Composition requires an eye for aesthetics and balance. Here, the composition has created an unbalanced look and feel.

FOCUS

With the image of the pier, the focus was set so that it softened the sand, allowing the pier and roller coaster to become the main topic of the image.

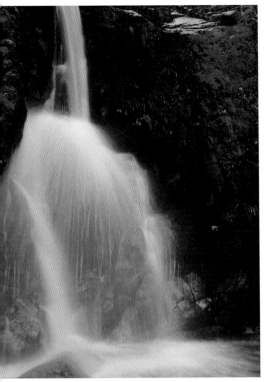

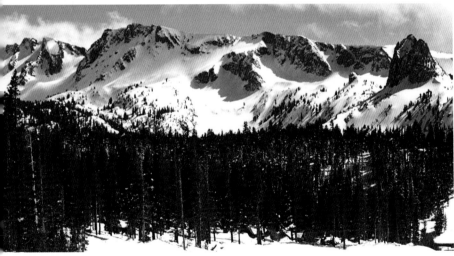

TRY THIS!

Sand dunes and hills • Shoot interesting rock sculptures • Trees in a field • Snow-capped mountains • Creeks or brooks • Covered bridges • Freeway rush-hour traffic • Fields of flowers • A unique-looking plant, such as a desert cactus • Look for long, winding roads

SPORTS

Sports photography is definitely one of my favorite venues. It's fast, exciting, and—when you get into a rhythm with the game—a poetic visual dance. I also like capturing the intensity that athletes show when they're competing. Whether it's a professional or someone's 10-year-old child, it's really the same look. In this photo of a professional tennis player, the intensity on his face makes for a great photo.

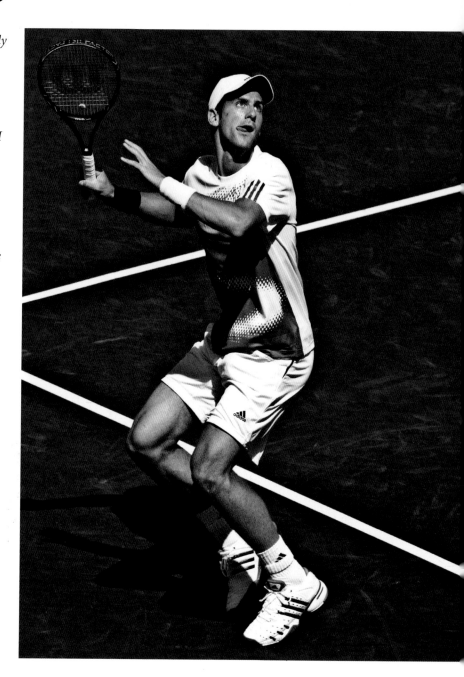

EQUIPMENT
LENS: 600mm f4.0 **TRIPOD:** Gitzo Carbon 3-Section **LIGHT:** Natural sunlight

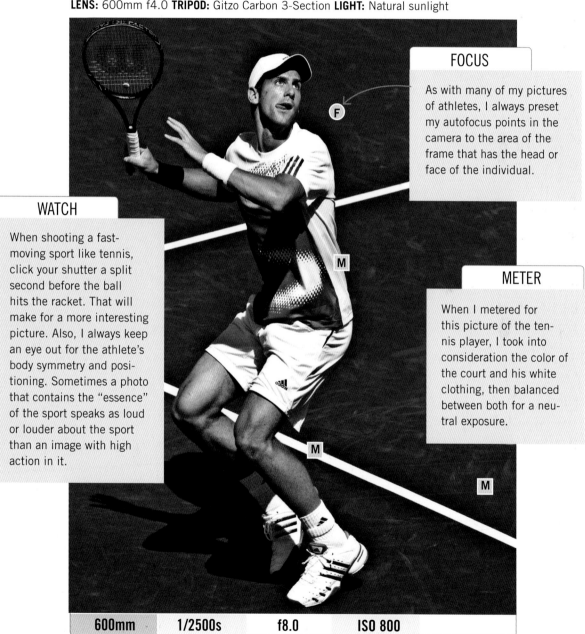

FOCUS

As with many of my pictures of athletes, I always preset my autofocus points in the camera to the area of the frame that has the head or face of the individual.

WATCH

When shooting a fast-moving sport like tennis, click your shutter a split second before the ball hits the racket. That will make for a more interesting picture. Also, I always keep an eye out for the athlete's body symmetry and positioning. Sometimes a photo that contains the "essence" of the sport speaks as loud or louder about the sport than an image with high action in it.

METER

When I metered for this picture of the tennis player, I took into consideration the color of the court and his white clothing, then balanced between both for a neutral exposure.

| 600mm | 1/2500s | f8.0 | ISO 800 |

GET IT RIGHT

If you're shooting with a long telephoto lens, make sure you shoot from a sturdy tripod, but also be sure you have the exact point of view you want. Set up your camera, look through the lens, and pan left to right to mimic an athlete running thoughyour frame to see if you like the overall composition.

EXPOSURE

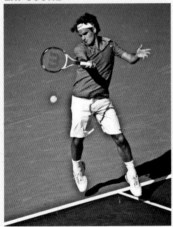

At first glance, the exposure of this image looks fine. But because the midday lighting is directly over the tennis player's head, it has created unpleasant and very dark shadows around his eyes.

COMPOSITION

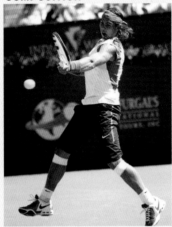

Composition is more than just squaring up a person in the frame and shooting away—it's truly an art. You are telling a story through the combination of your lighting, the use of lenses, and your depth of field, among other techniques.

FOCUS

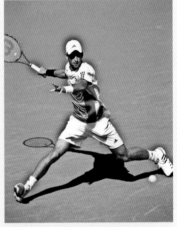

Focus truly brings your pictures to life. With this shot of the tennis player, I anticipated his full-speed running slide to get to the ball and set my focus to accommodate for a razor-sharp image of it.

DO

Move around so you can change your angles and lighting. Mix it up!

Anticipate where the action is going—stay alert and follow along with it.

DON'T

Don't always stay with one shutter speed and aperture setting the whole time you're shooting.

Avoid composing your shots too tightly or too loosely.

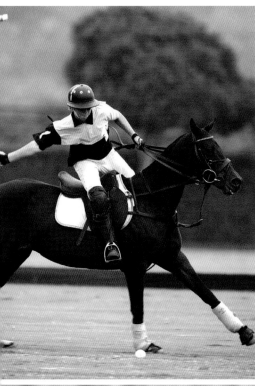

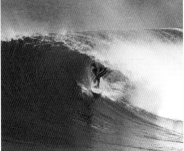

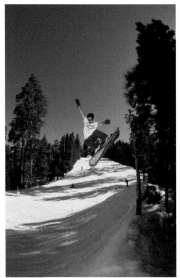

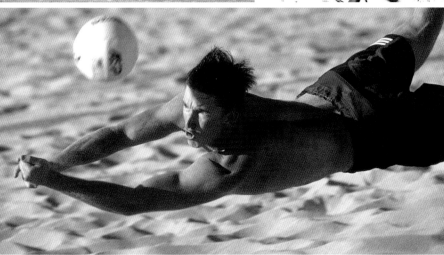

TRY THIS!

Running alongside the action • Athlete running and jumping in the air over the camera • Shoot portraits of athletes with their equipment still on • Use very fast shutter speeds to freeze the action • Motion pan blurs with slow shutter speeds • Use a flash unit or multiple units • Crowds at the sports event

ANIMALS AND PETS

Animals have great personalities, and many of them seem to enjoy mugging for the camera. Shooting your pets can go from a simple portrait of them—as in this image of my cat seated next to a teddy bear—to a more intense action shot of them running and jumping through the air. And you can always catch wild animals at the zoo or— if you're lucky and adventurous enough—in their native habitat at an animal preserve.

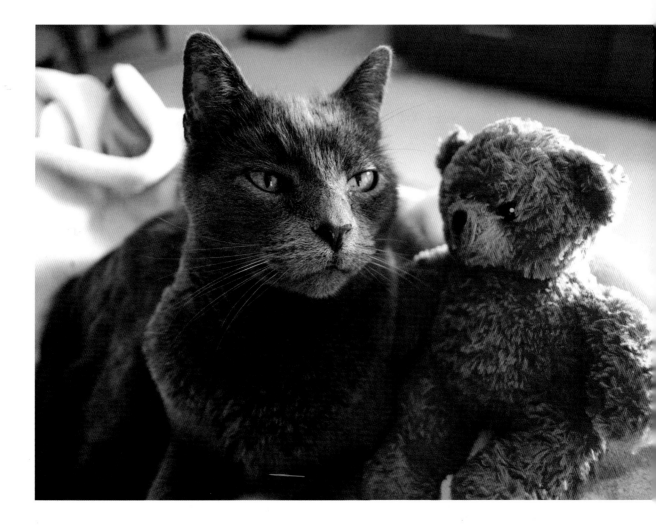

SET IT UP

EQUIPMENT

LENS: 35mm f2.8L IS USM **TRIPOD:** None **LIGHT:** Natural ambience balanced with flash

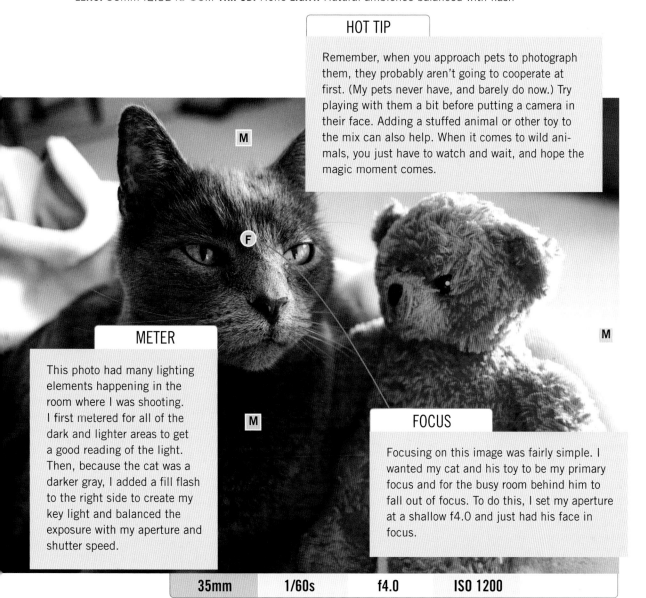

HOT TIP

Remember, when you approach pets to photograph them, they probably aren't going to cooperate at first. (My pets never have, and barely do now.) Try playing with them a bit before putting a camera in their face. Adding a stuffed animal or other toy to the mix can also help. When it comes to wild animals, you just have to watch and wait, and hope the magic moment comes.

METER

This photo had many lighting elements happening in the room where I was shooting. I first metered for all of the dark and lighter areas to get a good reading of the light. Then, because the cat was a darker gray, I added a fill flash to the right side to create my key light and balanced the exposure with my aperture and shutter speed.

FOCUS

Focusing on this image was fairly simple. I wanted my cat and his toy to be my primary focus and for the busy room behind him to fall out of focus. To do this, I set my aperture at a shallow f4.0 and just had his face in focus.

35mm	1/60s	f4.0	ISO 1200

GET IT RIGHT

When shooting pets or animals, remember they are probably not used to someone putting a strange-looking black box in front of them. Try to anticipate your shot and not let them know you're shooting. You can also work to get them accustomed to you and your camera by always having the camera when in their presence.

EXPOSURE

The tricky part about shooting animals or your pet is that you always have to be fast. With this image, I used the evaluative metering auto exposure setting on the camera, thereby properly exposing for the foliage and the background, while the cat itself was underexposed.

COMPOSITION

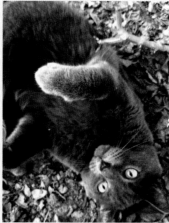

When you're composing a shot with your pets, be ready for just about anything. My cat allowed me to capture a couple of normal, sitting-upright photos before deciding it was time to roll around and get his belly rubbed, as you can see in this image.

FOCUS

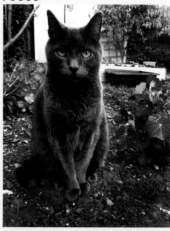

This photo was composed at the eye level of my cat. Lying in the bushes in front of him to focus was not an option because he'd probably run away. So I simply turned on the live view mode in the camera to frame him, preset my focus to be about 2 feet away, and began shooting.

DO

Use a flash unit—or anything that can reflect light back on your subject—when shooting toward the sun or if the animal is dark in color.

Have patience when shooting with animals, as they spook easy and will turn away from you.

DON'T

Don't frame your subject too tightly, or you'll lose the overall effectiveness of the entire photo.

Try not to interfere with the animals too much. Let them be spontaneous, and capture what they're doing.

TRY THIS!

Shoot animals in groups • Animals and people interacting • Photograph large mammals at local aquarium • Shoot young kids with animals • Dogs playing in the snow • The challenge of birds in flight • Try shooting very small animals, like insects or frogs • Photograph animals at the zoo • Try a formal portrait of the family pet

ANIMALS AND PETS 117

FLOWERS

*Throughout history, flowers
have been the subject of master
photographers and acclaimed
painters. Many aspiring
photographers have learned
the intricacies of their craft
by studying these incredible
works, some of which date back
centuries. With this image of
a beautiful stemmed red rose,
I wanted to show the juvenile
petals just prior to full bloom.*

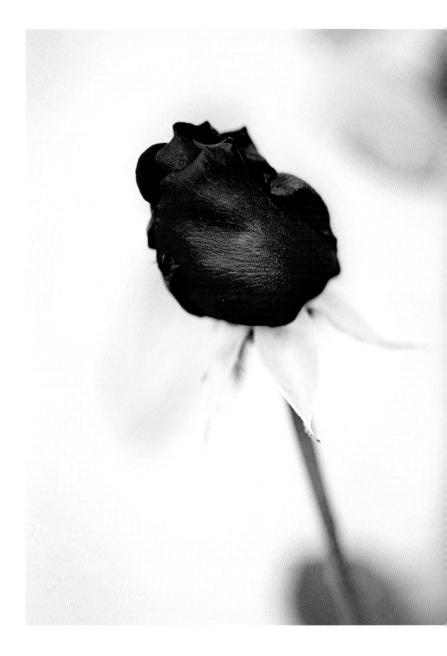

EQUIPMENT

LENS: 100mm f2.8L Macro IS-USM **TRIPOD:** Yes **LIGHT:** Natural ambience balanced with a white card

WATCH

When shooting flowers or other foliage, try using a macro lens so you can get extreme close-ups of the detail. And don't forget to use a sturdy tripod.

METER

By metering on the red rose, followed by the yellow foliage and green leaves, I kept the colors neutrally balanced. That way, my brighter background could frame the flower and allow it to really pop.

FOCUS

When I set out to create the image of this stemmed red rose, I wanted to show the shapes and texture of the pre-bloomed petals. To accomplish this, I focused purely on the front petal and allowed my very shallow depth of field to create an out-of-focus effect on the rest of the image.

| 100mm | 1/100s | f4.0 | ISO 100 |

GET IT RIGHT

When shooting flowers—or any cool-looking foliage or leaves—remember to walk around and look at the many different angles. You may like the way the light is illuminating the petals from a certain angle, or you may decide to backlight them to create a translucent effect where you can see the veins and texture better.

EXPOSURE

Shooting flowers often requires a little extra thought when creating your exposure. With this image of the white rose, I used a diffused lighting setup to create a softer exposure palette, allowing the flower to be the primary emphasis.

COMPOSITION

When composing this shot, I wanted the image to be more about the simplicity of the flower than the surrounding garden area where it was planted. Its shape and tonality of color really struck me as being the powerful force of its beauty.

FOCUS

As I've discussed many times, focus is the key factor to telling the story of an image. With this photo of the white rose, I chose to only focus on the interior petal and its seed pod and allowed both the foreground and background to softly frame them.

DO

Use various types of bounce cards and diffused lighting tools.

Explore different focal-length lenses, and remember to use a macro lens to get extreme close-ups.

DON'T

Don't shoot in windy conditions; your flower could be blown out of the proper focus area.

Never shoot in direct sunlight when working with delicate flowers that are light in color.

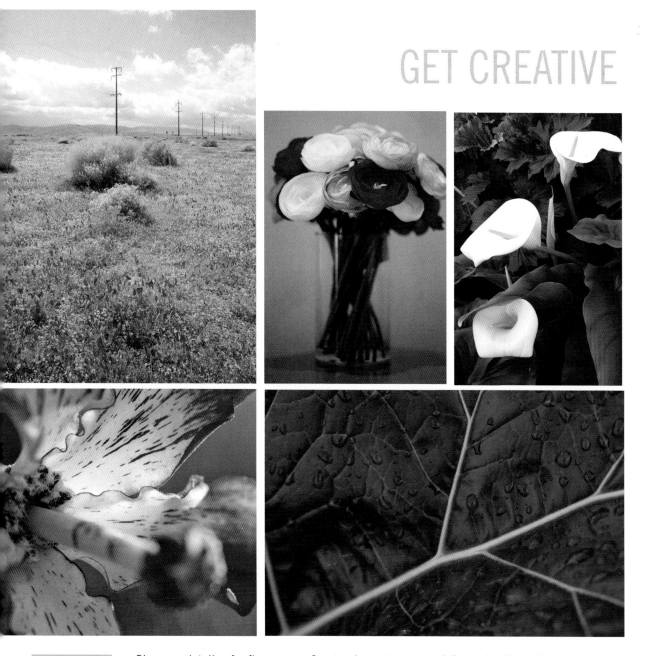

TRY THIS! Close-up details of a flower • Create abstract art • A flower in silhouette • Spray water droplets on the petals for a special effect • A bouquet of various flowers and colors • Shoot with a bee or butterfly on it • Flowers in creative and colorful vases • Shoot in various lighting palettes on a windowsill • Place flowers in a lady's hair or on her clothing as a prop

VACATION AND TRAVEL

You can really find some great photo opportunities when you travel. Recently my family took a vacation to the Hawaiian island of Kauai for fun and relaxation with some friends. As my friends' daughter was playing in the sand, I noticed she looked like a crumb-doughnut baby engulfed in the warm tropical light. The sand, water, and sky allowed me to frame a picture that would tell a more complete story, so I quickly grabbed my camera and began to shoot away.

EQUIPMENT

LENS: 28mm f2.8 **TRIPOD:** None **LIGHT:** Natural ambience balanced with flash

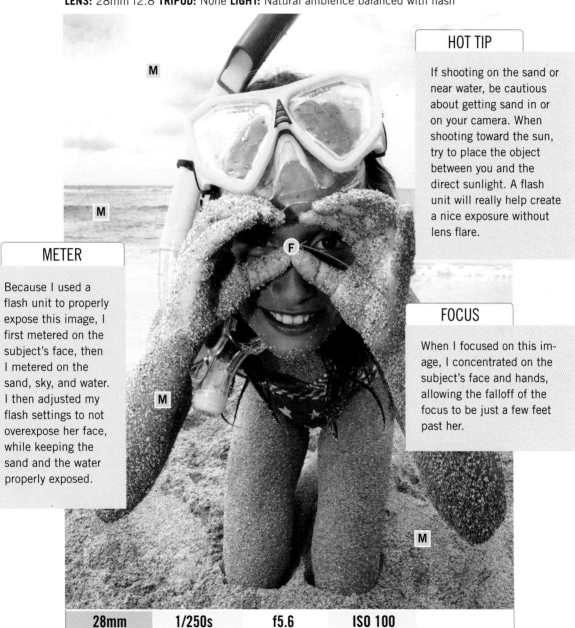

HOT TIP

If shooting on the sand or near water, be cautious about getting sand in or on your camera. When shooting toward the sun, try to place the object between you and the direct sunlight. A flash unit will really help create a nice exposure without lens flare.

METER

Because I used a flash unit to properly expose this image, I first metered on the subject's face, then I metered on the sand, sky, and water. I then adjusted my flash settings to not overexpose her face, while keeping the sand and the water properly exposed.

FOCUS

When I focused on this image, I concentrated on the subject's face and hands, allowing the falloff of the focus to be just a few feet past her.

| 28mm | 1/250s | f5.6 | ISO 100 |

GET IT RIGHT

When shooting outdoors, make sure you take into account how certain elements can affect color temperatures. For example, sand can be a source of reflection and bounce warm light onto your subject. Or if it's cloudy and you're near water, you can get a cold, bluish look.

EXPOSURE

Underexposing your image can ruin a potentially great photo. In the image above, the underexposed, darkened frame not only changes the look of the subject, but also makes the entire environment appear uninviting.

COMPOSITION

Proper composition is everything in a great picture. You are telling a story about not just the subject, but also the location and the beauty of the area. With this picture, the cropping is too tight and too close to the subject to tell the complete story.

FOCUS

Improper focus can ruin any picture. The focus here was not on the girl's face or hands and has created a soft and unusable image.

DO

Use a white bounce card, or any source of white material, to reflect light on to your subject's face.

Use a flash unit when shooting into the sun.

DON'T

When not shooting pictures, you shouldn't leave your camera exposed to the elements.

Try not to interfere with what your subject is doing or you'll lose the spontaneity of the moment.

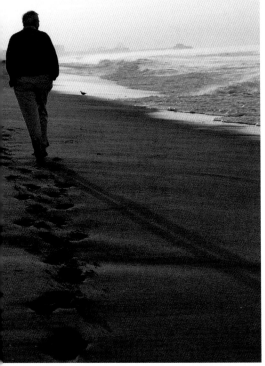

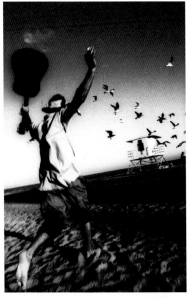

TRY THIS!

Shoot a close-up of someone smiling • Running and jumping in the air • Group photos with friends • Running through the white water • A street or alley of an exotic locale • Use swimming fins and snorkel masks as props • Making faces at the camera • Building sand castles • Get a shot of a group in front of an iconic building

PORTRAITS

Of all the pictures you can create, the portrait is perhaps the most powerful. When shooting portraits, take your time to study the angles and dimensions of your subject's face. Notice how he or she fits into the surroundings of your stage. With this image of the man's face, I wanted to create a scenario where the viewer is drawn directly into his eyes.

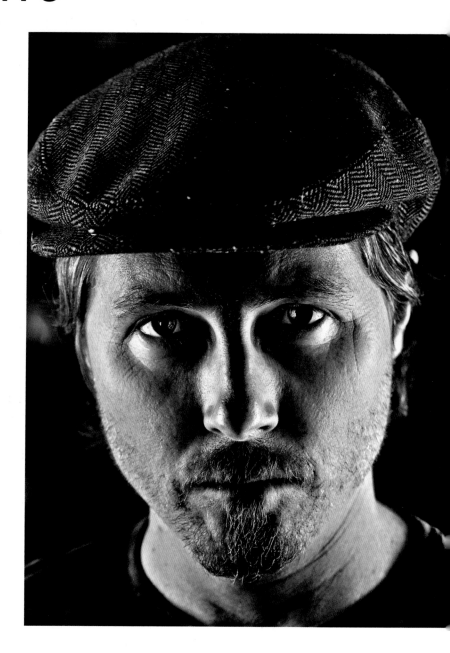

EQUIPMENT

LENS: 100mm f2.8L Macro IS USM **TRIPOD:** None **LIGHT:** Multiple strobes and bounce cards

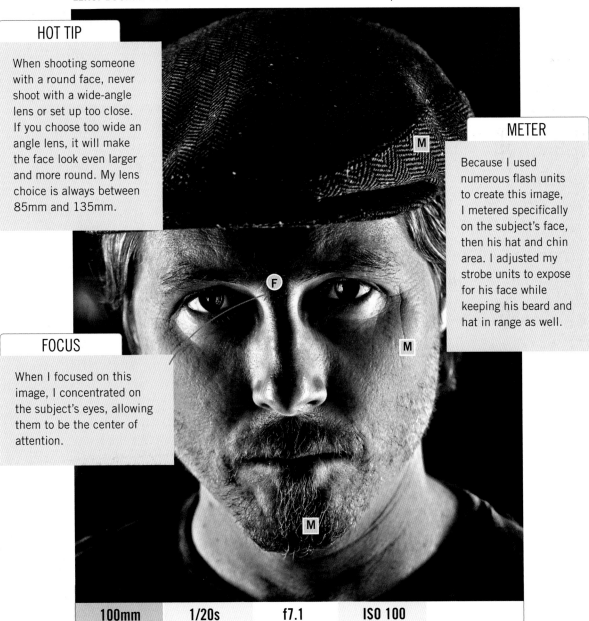

HOT TIP

When shooting someone with a round face, never shoot with a wide-angle lens or set up too close. If you choose too wide an angle lens, it will make the face look even larger and more round. My lens choice is always between 85mm and 135mm.

METER

Because I used numerous flash units to create this image, I metered specifically on the subject's face, then his hat and chin area. I adjusted my strobe units to expose for his face while keeping his beard and hat in range as well.

FOCUS

When I focused on this image, I concentrated on the subject's eyes, allowing them to be the center of attention.

| 100mm | 1/20s | f7.1 | ISO 100 |

GET IT RIGHT

To truly create magical portraits, you want to tell a story. You must capture who they are, allow the portrait to speak to their lives, and do so without inserting yourself in the middle. Really good portrait photographers put their subjects at ease and allow them to feel both safe and vulnerable at the same time.

UNDEREXPOSED

Underexposing your image creates a very unflattering photograph, as you can see in this example. It will take away all the important and subtle details that you are trying to capture as part of your story.

COMPOSITION

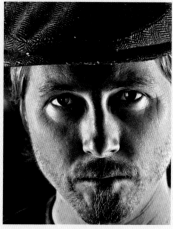

A great portrait begins with composition and cropping. You are telling a story about not only the subject, but the kind of life this person has led. By this image being cropped too tightly and too far left, the result is an imbalance to the overall picture.

FOCUS

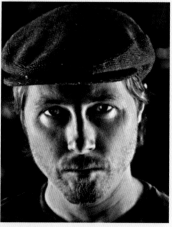

Focus is a primary concern for everyone when creating a quality portrait. As the focus shifted forward on this image to the brim of the hat, it made the entire face soft and unreadable.

DO

Capture the essence of your subject.

Set your aperture so that you have ample focus depth.

DON'T

Avoid shooting with too slow a shutter speed.

Don't get too creative and tilt the camera in an aggressive manner.

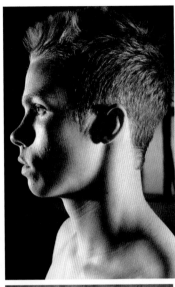

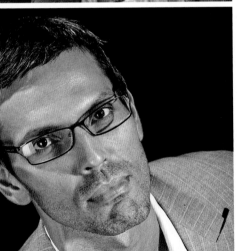

TRY THIS!

Shoot next to a reflective surface or mirror • Profiles • Shoot with only side lights • Shoot from atop a ladder • Through a steamy shower door • Find an environment that adds to your story • Concentrate on a single facial feature, like an eye • Add props to your subject • Black and white shots

LANDMARKS AND HISTORICAL SITES

When you're shooting landmarks and historical sites, you're creating your rendition of a subject that many have photographed or even painted countless times. I always try to include the complete story of the location, so someone who has never been there can easily get a feel for the entire place by merely looking at my photograph. That principle applies here to the picture of the famous Griffith Observatory, which is on a hilltop west of Hollywood and east of downtown Los Angeles.

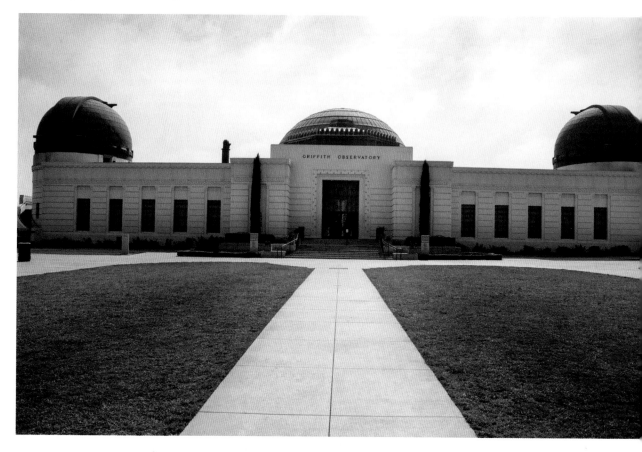

SET IT UP

EQUIPMENT
LENS: EF 24mm f1.4L II USM **TRIPOD:** Yes **LIGHT:** Natural ambience

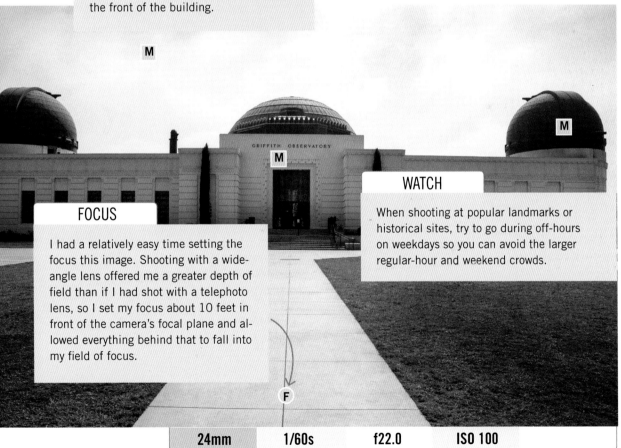

METER

Metering the exposure for this shot was a bit complicated. Because I shot at mid-day, I had to consider the white of the building and the clouds, followed by the darker, shaded areas of the roof line and the front of the building.

FOCUS

I had a relatively easy time setting the focus this image. Shooting with a wide-angle lens offered me a greater depth of field than if I had shot with a telephoto lens, so I set my focus about 10 feet in front of the camera's focal plane and al-lowed everything behind that to fall into my field of focus.

WATCH

When shooting at popular landmarks or historical sites, try to go during off-hours on weekdays so you can avoid the larger regular-hour and weekend crowds.

| 24mm | 1/60s | f22.0 | ISO 100 |

GET IT RIGHT

Consider taking a guided tour of the landmark or historical site you plan to shoot to both scout the location and access areas you might not be allowed to on your own. Also, keep in mind that you'll likely encounter crowds of people who are there to visit and enjoy the site when you're shooting. While you may get frustrated as people continually move in and out of your shot, it's something you'll have to work around.

EXPOSURE

I wanted to show the Los Angeles skyline in the background, but because it was in a cloud formation, it was hard to see. Therefore, I set my exposure to be able to illuminate the buildings but not blow out the skyline.

COMPOSITION

Here, to tell the best story, I composed my shot at the top viewing area of the observatory so I could show the surrounding hillside, the walking ramp, the stairway, and, of course, the famous Hollywood sign in the background.

FOCUS

I really like to use my focus as a selling point for my images. Here, I composed a series of archways that surround the famous Hollywood sign but set my focus on the second archway to draw the viewer's eye to the sign on the hillside.

DO

Take the time to explore unique angles and points of view that many may not stop to consider.

Check with your local historical society to find out about different places in your area you can shoot.

DON'T

Avoid just walking up, pointing, and shooting—take your time to set up a shot.

Try not to interfere too much with whatever the site has to offer. It should be preserved in pristine conditions for generations to come.

TRY THIS! Panoramic photos of the historical site and surrounding area • A landmark from both up close and far away • Shoot after dark, if the historical site is open and well lit • A black-and-white photo of a very old landmark • Use the crowds to enhance show the popularity of a landmark • Close-ups of entranceways and other standout features of a historical site • Show how the aging process has affected a landmark in your photo

FOOD

Photographing food is one of the more intriguing disciplines for both amateur and professional photographers. It can be anything from a simple dessert-plate setting to an avant-garde placement of a three-tiered masterpiece like you see here. In the end, the real trick is to tell the story of the food being captured through the ambience, props, and lighting. And, if you're lucky, you may also have something good to eat after the shoot.

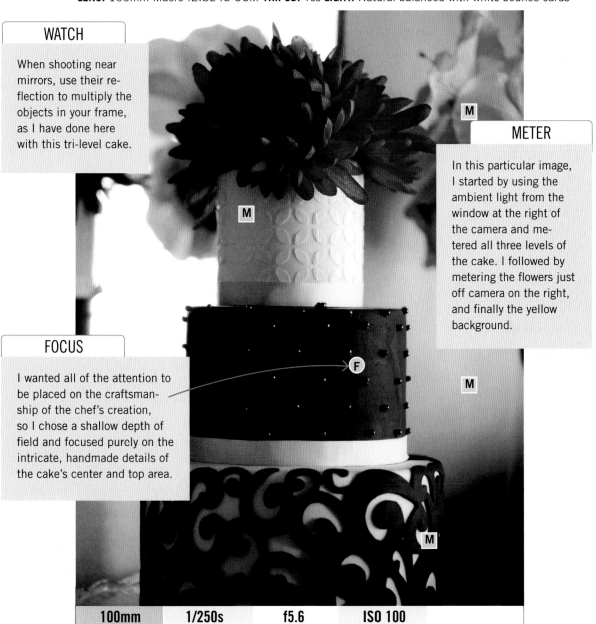

SET IT UP

EQUIPMENT
LENS: 100mm Macro f2.8L IS USM **TRIPOD:** Yes **LIGHT:** Natural balanced with white bounce cards

WATCH

When shooting near mirrors, use their reflection to multiply the objects in your frame, as I have done here with this tri-level cake.

METER

In this particular image, I started by using the ambient light from the window at the right of the camera and metered all three levels of the cake. I followed by metering the flowers just off camera on the right, and finally the yellow background.

FOCUS

I wanted all of the attention to be placed on the craftsmanship of the chef's creation, so I chose a shallow depth of field and focused purely on the intricate, handmade details of the cake's center and top area.

| 100mm | 1/250s | f5.6 | ISO 100 |

GET IT RIGHT

When shooting food—whether you are in your home, at a café, or anywhere in between—always pay close attention to your composition and lens choice. If you're not sure what options will work best for you, experiment and study the various results. Both offer numerous options, so you'll surely find a way to shoot food in a style you like.

DO

Go out to lunch and have fun "test" shooting your meals.

Take into consideration whether it's an outdoor or indoor setting when composing your shot to tell the story of the food.

DON'T

Try not to only shoot with a shallow depth of field.

Avoid sticking to one lens when shooting a variety of food topics.

EXPOSURE

If you're setting up your exposure outdoors, be sure to allow the light to match the scene. In this shot, I allowed the warm afternoon sunlight to become part of my storytelling process.

COMPOSITION

When composing pictures of food, keep the composition simple and uncluttered. As you can see here, having too many items can make an image appear cramped.

FOCUS

In food photography, focus is key to telling the story. In this picture, I wanted to showcase the lemonade beverage, so I made that my focus.

GET CREATIVE

TRY THIS!

Shoot the "spread" at a party or event • Food displays at a grocery store, bakery, or produce stand • Try mixing colors and shapes of various foods for an artistic effect • Take a shot of the entire table just after the food has been served • A "still life" shot with a variety of different foods • Shoot vegetables as they are harvested from a garden • Extreme close-ups of a variety of different foods

SEASONS

The interesting thing about shooting the different seasons is that, regardless of where you live, changing seasons are always available to shoot. Obviously, some areas are more visually striking than others, but you can always find something interesting to shoot as the seasons pass. A perfect example is this photograph of the ancient Valley Oak trees on an autumn day in the hills above Malibu, California.

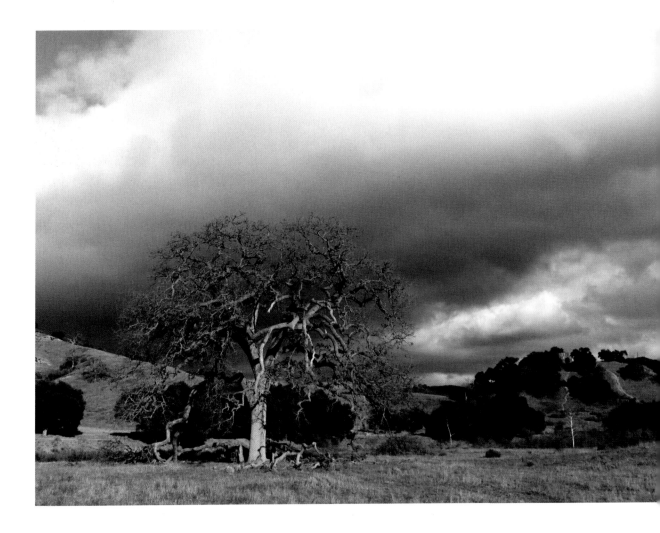

SET IT UP

EQUIPMENT
LENS: 50mm f1.2L **TRIPOD:** None **LIGHT:** Natural ambience

HOT TIP

When shooting the various seasons throughout the year, try to shoot at the most visually dramatic time of day—typically in the morning. You can also get some great shots when a change in weather adds drama to the sky or landscape.

METER

When I metered this image of the ancient Valley Oak tree with the hills in the background, I took into account the blue sky and the feel of the clouds, the tree in my foreground, and the basin floor. Because I was only exposing with natural light, I made certain that the entire image was properly exposed for the look I wanted to capture.

FOCUS

The focus for this particular shot was first placed on the tree in the middle of the frame, then pulled back toward the camera a bit to make sure I also had my foreground sharp.

| 50mm | 1/1250s | f5.6 | ISO 100 |

GET IT RIGHT

It's easy to shoot the seasonal changes in areas where they're very pronounced, but you really need to pay close attention to your composition, your shadow detail, and the angle of your lighting. Don't let the vivid colors or dramatic scenery take you away from creating an image that truly shows the power and beauty of the season.

EXPOSURE

In this image of the Valley Oak tree, I set my exposure on the darkened, cloud-filled sky in the background to frame the tree branches so the branches added drama and intensity to the picture.

COMPOSITION

When you're shooting seasonal pictures, such as this Valley Oak tree and the surrounding hills, make sure you leave plenty of space around the subject to truly show the overall scene.

FOCUS

When creating sharply focused pictures, you should also create a density or contrast palette so the color and variances of your foreground and background separate from each other, as I did in this image.

DO

Experiment with negative space.

Try using numerous types of filters, both color enhancing and color correcting.

DON'T

Try not to use only one aperture and shutter-speed setting.

Don't only shoot in the middle of the day or when it's most convenient.

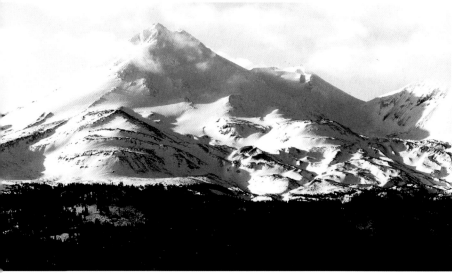

TRY THIS!

Macro close-up shots of leaves or branches • Look for wildlife with offspring • Seasonal sporting activities • Shoot the same scene in the different seasons, but mix up the lens choice each time • Landscape changes caused by the seasons • Extreme wide-angle shots of lakes and ponds • Look for an isolated tree in a field and shoot with a lot of negative space around it

NIGHT SHOTS

Throughout the course of learning to shoot a variety of wonderful pictures, capturing properly exposed night shots will likely be the most challenging. But rest assured, after sharing a few exercises and tips with you, night shooting won't be quite the daunting task it appears to be. As you can see in this picture of fireworks over a pier, night shooting is all about getting the lighting just right.

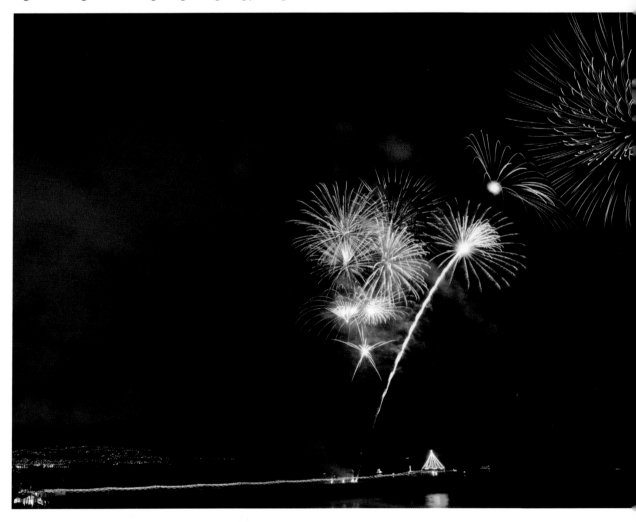

SET IT UP

EQUIPMENT
LENS: EF24mm f2.8L USM **TRIPOD:** Gitzo Carbon 3-Section **LIGHT:** Natural ambience

WATCH

When shooting fireworks, a sturdy tripod is a must. Also, remember to set your camera's shutter function setting to the "B" or Bulb setting so you can control the shutter-speed variations as you like. From there, set your aperture to a smaller value (larger number) so it allows for the proper exposure to go with a very long shutter speed. Once the action starts, you'll be ready to go.

METER

Metering to properly expose fireworks is actually pretty simple once you get the hang of it. Every shot will be at a very long shutter speed—that's how you get the elongated streaks. So it's really all about balancing your varying shutter speeds with your aperture setting to get a good exposure. With this picture, I manually exposed my shot for 20 seconds at f/16, then let the fireworks streak through the night sky.

FOCUS

When I set the focus to capture fireworks, I first make sure I have my base foundation in focus—such as the pier in this image. From there, I allow the fireworks action to fall within my preset depth of field.

| 24mm | 20s | f16.0 | ISO 100 |

GET IT RIGHT

When shooting at night, make sure you set your exposure settings in advance. Also, remember to adjust your white balance settings to account for the light shifting colors due to cooler color temperatures.

EXPOSURE

As I've said before, exposing night shots can get tricky. But by adding a flash unit to my camera, I was able to properly expose and freeze the action of a father and his daughter on the bumper cars.

COMPOSITION

Because the lack of available light makes it difficult to see through the camera the same way as on a bright day, I often give myself a little extra negative space to avert this potential problem.

FOCUS

As you can see in this example of a Ferris wheel, getting a sharp focus is critical. I used a slow shutter speed that could have resulted in a blurry image had my focus been slightly off.

DO

Use a flash unit when at all possible. When it's not feasible, elevate your ISO setting and use a large aperture setting.

Remember that the lighting on your subject will be emphasized even more due to the sky and backgrounds being much darker.

DON'T

Try not to use your flash unit when it's set to a high output if your background is too bright.

Don't hold your camera in your hands if your shutter speed is dialed to a very slow setting.

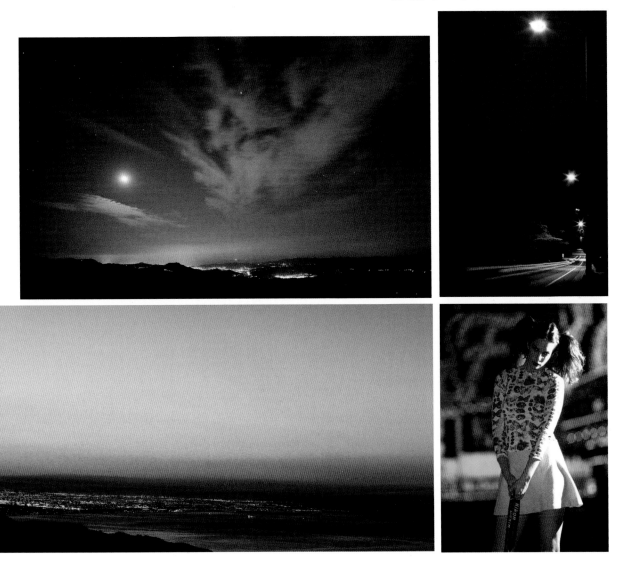

TRY THIS!

A single candle on a romantic dinner table • A time lapse with cars driving on the freeway • At night during the rain or when the lights are reflecting off the wet pavement • Use an on-camera flash with streetlights • Snowflakes falling with night lights illuminating them • Silhouette of your subject against a light in the background

EVENTS

Events can be quite fun to shoot and be a part of at the same time. The variety of themes can be as wide as the Grand Canyon, and as such, the equipment needed to cover them can be vast as well. I've photographed numerous motor sports events around the world and, as with this image, I always try to capture the race from the eyes of a spectator looking at the full story.

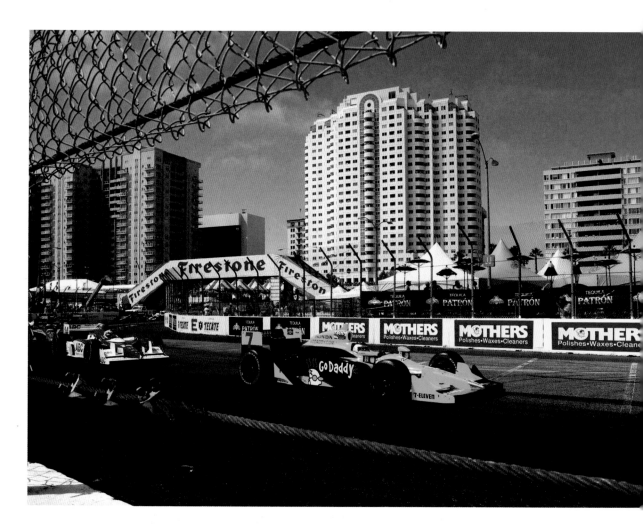

SET IT UP

EQUIPMENT
LENS: 17–35mm f2.8 **TRIPOD:** None **LIGHT:** Natural balanced

HOT TIP

When shooting events like this motor sports race, always be on the lookout for interesting angles that will give your photos a sense of the viewer "being there" with you. Be sure to mix up your lenses and shutter speeds as well.

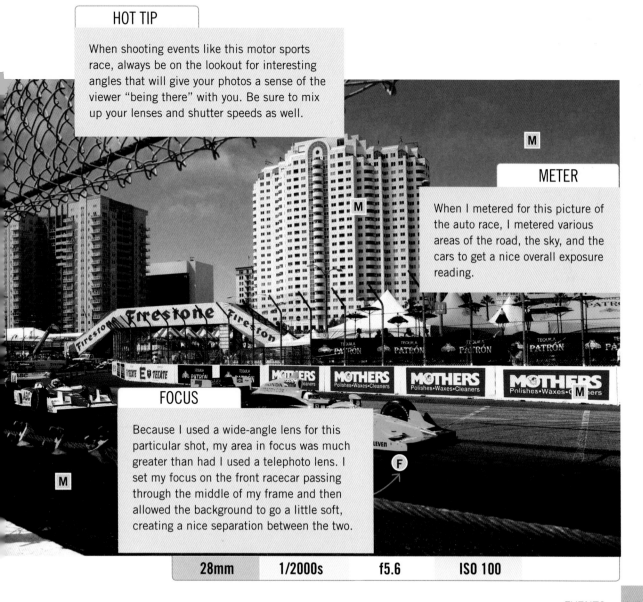

METER

When I metered for this picture of the auto race, I metered various areas of the road, the sky, and the cars to get a nice overall exposure reading.

FOCUS

Because I used a wide-angle lens for this particular shot, my area in focus was much greater than had I used a telephoto lens. I set my focus on the front racecar passing through the middle of my frame and then allowed the background to go a little soft, creating a nice separation between the two.

| 28mm | 1/2000s | f5.6 | ISO 100 |

GET IT RIGHT

You must prepare for numerous things when shooting at events. Have a high-quality midrange zoom lens that can cover a wide range of focal lengths. And remember to always be attentive and on your toes. Things happen fast, and they never repeat themselves. If you miss something, just move on—but stay alert.

DO

Look for numerous angles from which to shoot, including overviews of the event and its participants.

Walk the event location to check the necessary areas for your exposure readings and any places that may offer a unique perspective.

DON'T

Don't allow distracting objects or too much negative space in the foreground of the photo.

Don't be afraid to walk in front of or command the entire event in order to shoot a photo.

EXPOSURE

While exposure is fundamental to creating a quality picture, using a high-key background as a source to place the subject is what makes this image stand out.

COMPOSITION

By composing my image with an overview of the race, the combo of the buildings, fans, and cars made a powerful image.

FOCUS

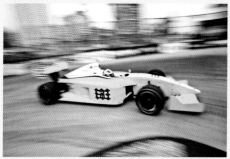

Things happen very fast at events, so focus is critical. With this image, I adjusted my focus so that the image was sharp, but I also slowed my shutter speed down to create the illusion of speed.

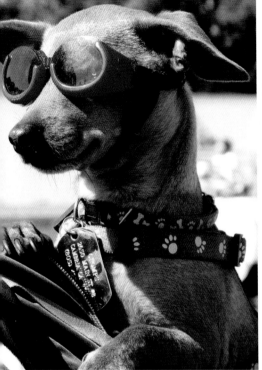

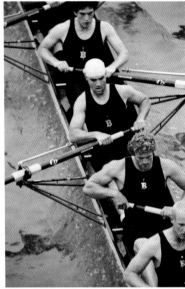

GET CREATIVE

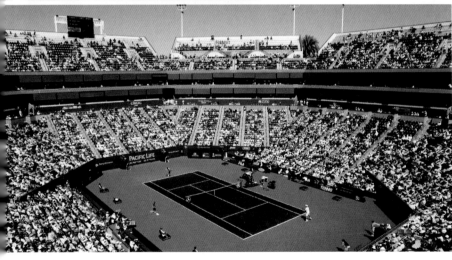

TRY THIS!

Shoot at sunset when the event is completely lit up • People toasting or making funny faces • Group people together • Get on a ladder and shoot down • Details of event decorations • Shoot behind obscure objects in the foreground • People cheering or clapping • Overview of the environment

FINE ART AND ABSTRACTS

The range of content you can shoot for fine art and abstract images is only limited by your imagination. Whether it's a vase of flowers or an old wooden fishing pier, as illustrated here, I always approach a fine art shoot looking to show the essence of whatever my subject may be.

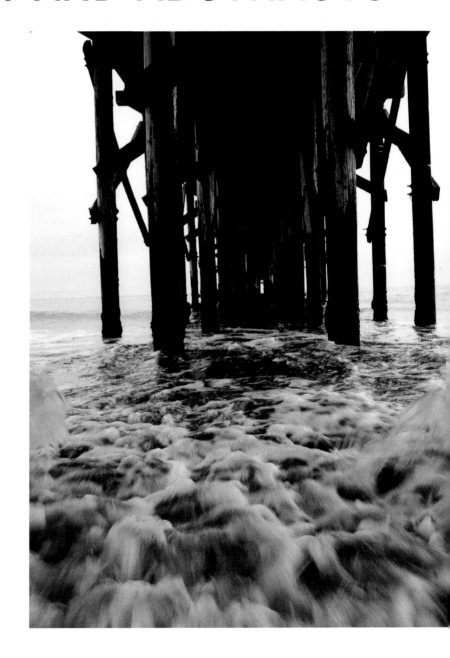

EQUIPMENT
LENS: EF 24mm f1.4L USM **TRIPOD:** None **LIGHT:** Natural ambience

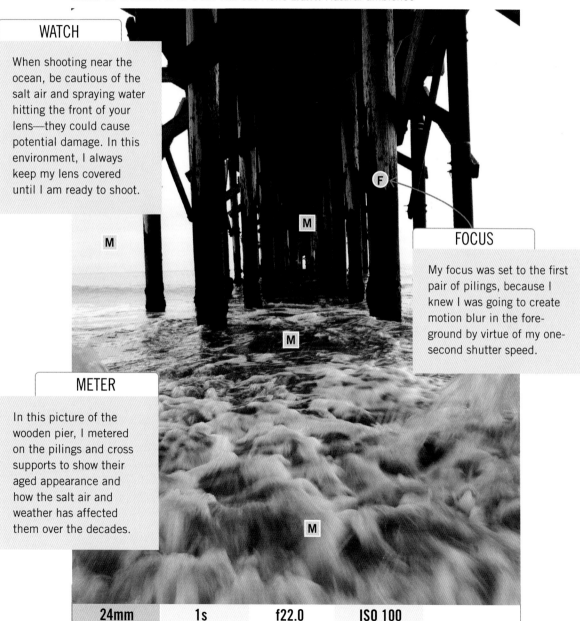

WATCH

When shooting near the ocean, be cautious of the salt air and spraying water hitting the front of your lens—they could cause potential damage. In this environment, I always keep my lens covered until I am ready to shoot.

FOCUS

My focus was set to the first pair of pilings, because I knew I was going to create motion blur in the foreground by virtue of my one-second shutter speed.

METER

In this picture of the wooden pier, I metered on the pilings and cross supports to show their aged appearance and how the salt air and weather has affected them over the decades.

| 24mm | 1s | f22.0 | ISO 100 |

GET IT RIGHT

Creating fine art or abstract images is really an expression of your vision. So experiment and explore the infinite possibilities you have for subject, lens type, angles, and lighting.

EXPOSURE

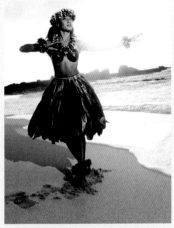

It can be difficult sometimes to properly expose an image when you're shooting directly back at the sun. With this picture, I balanced the exposure of the dancer with a fill flash and illuminated the details of her front side.

COMPOSITION

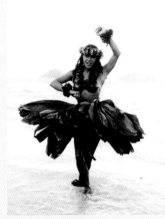

Especially in fine art and abstract photography, composition is about getting your vision across. When I composed my shot, I made sure to compose the picture with the outer islands behind her to create the feeling of a tropical location.

FOCUS

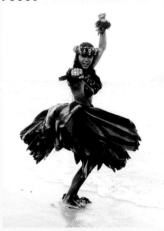

When you set your focus on a subject that will have motion to it—such as this hula dancer's skirt—make sure you also give yourself ample depth of field, or parts of your frame will appear out of focus.

DO

If you're shooting an antique object, try to show all the details of the craftsmanship.

When shooting fine art photos of people, look to create a sculpture of them, not just a picture.

DON'T

Try not to change the subject's details with your lighting or photographic techniques—keep it authentic.

Avoid using the same lens for everything you shoot.

GET CREATIVE

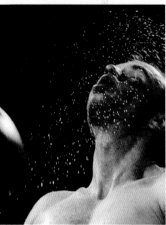

TRY THIS!

Shoot though a window while water drips down it • Close-up of flowers • Focus to infinite • In foggy or rainy conditions • Shoot with a soft focus filter • Macro close-ups of your subject • Shoot artifacts in a museum, if allowed • People in period costumes • Shoot in black-and-white for an "old" look

DYNAMIC ACTION

Dynamic action photographs require a great deal of skill, concentration, and patience. When I was shooting the photo of the horse jumping the gate, it took a while to work up the courage to crawl beneath the gate to get the shot I wanted. But my confidence grew as I studied the horse's subtle movements. I set up strobe lights first so the horse could become comfortable with the units popping as he jumped. Then I stood next to the gate as he jumped a few more times before I finally crawled below and began to shoot.

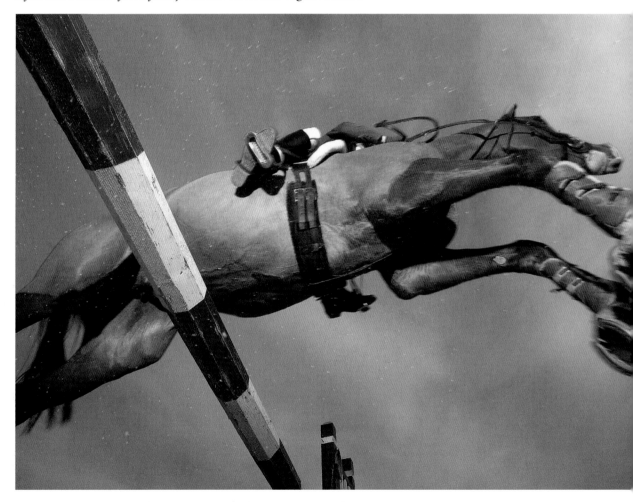

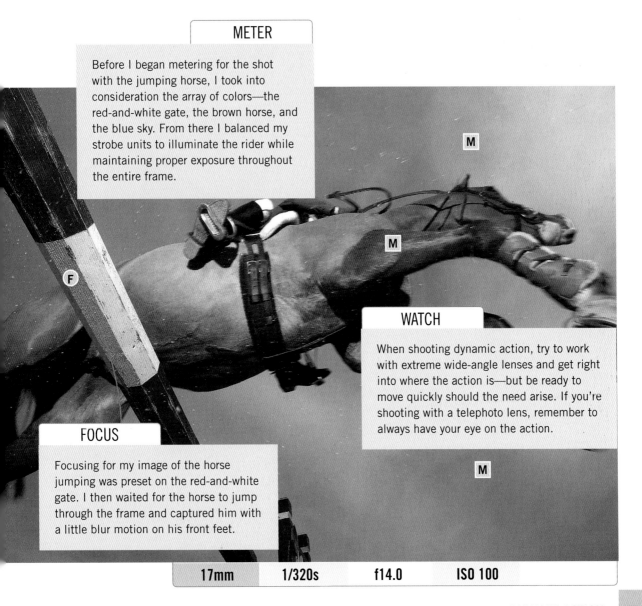

EQUIPMENT

LENS: 17mm f2.8 **TRIPOD:** None **LIGHT:** Natural ambience balanced with flash units

METER

Before I began metering for the shot with the jumping horse, I took into consideration the array of colors—the red-and-white gate, the brown horse, and the blue sky. From there I balanced my strobe units to illuminate the rider while maintaining proper exposure throughout the entire frame.

WATCH

When shooting dynamic action, try to work with extreme wide-angle lenses and get right into where the action is—but be ready to move quickly should the need arise. If you're shooting with a telephoto lens, remember to always have your eye on the action.

FOCUS

Focusing for my image of the horse jumping was preset on the red-and-white gate. I then waited for the horse to jump through the frame and captured him with a little blur motion on his front feet.

| 17mm | 1/320s | f14.0 | ISO 100 |

GET IT RIGHT

You have many things to prepare for when setting up to shoot dynamic action pictures. Your subjects typically move very fast, so you'll want to be ready to pan left or right quickly as needed. To do that, you can't be cramped in a tight spot. If you're shooting action with a longer telephoto lens, you'll want to shoot from a sturdy tripod that allows you to pan with your subject.

DO

Utilize a slower shutter speed to enhance the motion-blur effect of your picture.

Capture the spirit and essence of the action you're shooting.

DON'T

Don't turn your back on the action—ever!

Try not to let adverse weather interfere with your shoot.

EXPOSURE

By this image being underexposed, you cannot see the rider's face, nor can you see all the beautiful detail in the horse.

COMPOSITION

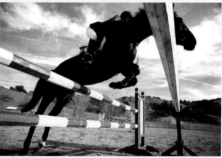

The composition of the jumping horse photo is not as effective as it should be because the front half of the horse has been cut out.

FOCUS

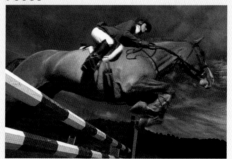

The focus here should have been on the horse and rider, but as the focus shifted past the rider, it made the horse appear much softer and blurred.

GET CREATIVE

TRY THIS!

Car races • Track-and-field events • Soccer or football games • Skiing or snowboarding • Shoot ocean sports like surfing • Kids skateboarding at the park • Swimming or diving in a pool • Make motion blurs of cars driving down the freeway at top speeds • Dogs or cats running and jumping • Mountain biking or road cycling

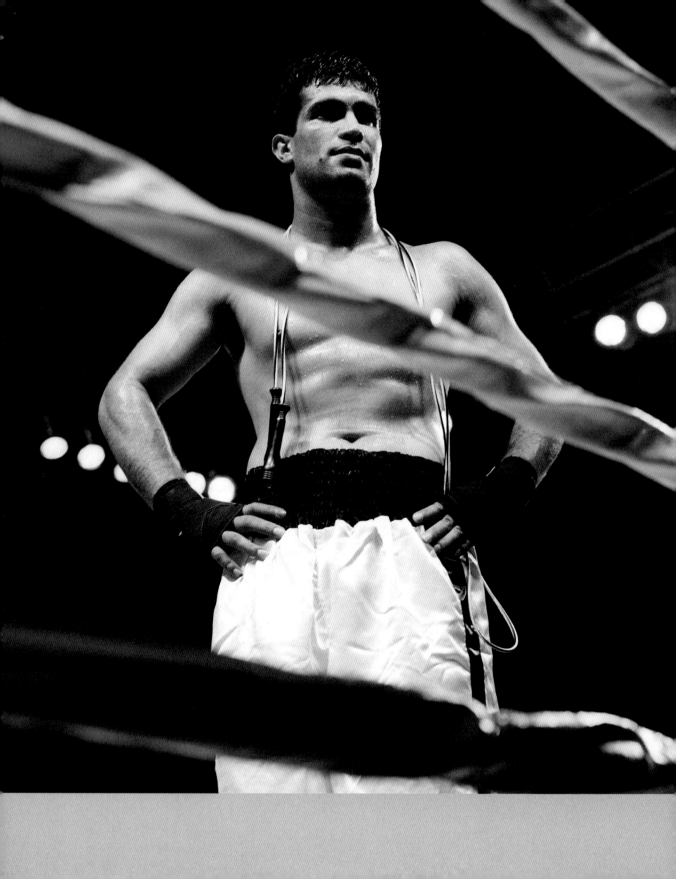

THE PROJECTS

With knowledge of the basic tenets of photography and how to shoot certain types of shots, it's now time for you to take your learning to the next level. I include projects that cover a range of shooting techniques, such as selective focus, macros and close-ups, panoramas, filters, sequences, and motion blur. For these, you'll see photos I've taken in each style and learn step-by-step how to take them yourself. I also provide some general tips and warnings about what to watch for when shooting using each technique.

To help you troubleshoot some common digital photography problems, I also provide projects for directing your subjects, working with mirrors and reflective surfaces, studying light, taking HD video with your camera, and transferring your photos. I walk you through each process and show you how I've personally dealt with these issues over the years.

As with any new skill you learn, practice is key—it's a process of trial and error, where experimentation is encouraged. Keep track of your efforts doing these projects by cataloging your photos and results on your computer. That way, you can note your progress as your photos and style begin to take on a professional bent.

The road to taking great photos might be bumpy in spots, but the finish line isn't as far away as you might think. These projects should serve as a start, a place from which you can embark on an even more complex photographic journey.

DIRECTING YOUR SUBJECT

With every shoot involving people, you have to wear a second hat—you assume the role of both a photographer and a director. It doesn't matter how the subject is participating in the shoot—for you to get the image you want, you must know how to direct that person. Once you gain some experience in this area, you'll get to a point where you can direct multiple subjects in a way that's acceptable and not considered "bossy" or "demanding."

This photo was from a shoot in which I was doing headshot portraits of a model for his portfolio. The model and I wanted an image that was fun and very summery, so to get it just right, I had to position him to the best advantage and then direct him in order to capture that look.

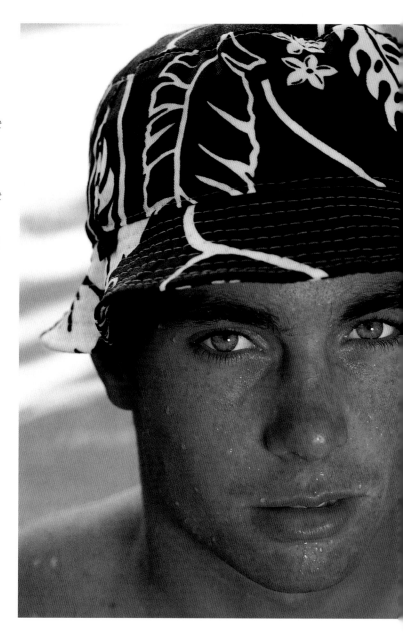

Equipment

Mode: Manual

Lens: EF 85mm f/1.2L II USM

Aperture: f/11

Shutter: 1/30 sec.

ISO: 100

Tripod: Three-section

Filter: None

Lighting: Strobe flash unit

The Setup

I set up alongside a pool so the light-blue water would be in the background and lend to the summery look of the image. Because I knew I would be shooting with a slow shutter speed, I made sure to bring along a tripod. I also had a strobe unit with me to add light onto his face as needed.

I then set up my tripod, weighted it down with a sandbag, attached my camera and lens, and added the subject.

If you're still pretty new to directing subjects, one mistake you can easily make is constantly telling your subjects what you *don't* want rather than what you *do* want. I learned this the hard way when trying to direct an actor friend in a photo shoot some years ago. I kept telling him what I didn't want until he stopped me cold and said, "Hey, it's easier if you just tell me what you want." That was an epiphany for me; I realized you're far more effective and will save a lot of time by simply telling your subject what you want. Stay positive, and you won't go wrong.

How to Shoot It

1. Position and reposition your subject until you're sure you've found the best angle for the kind of shot you want.

2. From there, determine the best position for optimal lighting by taking a meter reading of both the ambient light and the strobe's output with a light meter.

3. Based on the meter readings, adjust your aperture and shutter speed. After that, you can begin shooting.

4. While shooting, continue to direct your subject as needed to capture the shot you want. For my photo, I directed my model to make small changes in position and expression so I would have several looks from which to choose the best shot.

You can always direct a subject from behind the lens while you're shooting. But if directing behind the camera is something you sometimes do on a whim, be as prepared as you can with the other facets of your shoot, such as your lens, exposure, and lighting choices. The last thing you want to deal with are technical issues while the model stands around waiting for your direction.

When doing action photography, it's important for your model to hit the "mark" each and every time. For this photo of a motorcycle rider on a sweeping canyon turn, I needed my subject to hit an exact point in the road so he could be in a leaned-over position at a specific part of the turn each time he passed by the camera. In order to achieve this, I had to give clear and precise direction and correct any flaws on the first couple of practice passes.

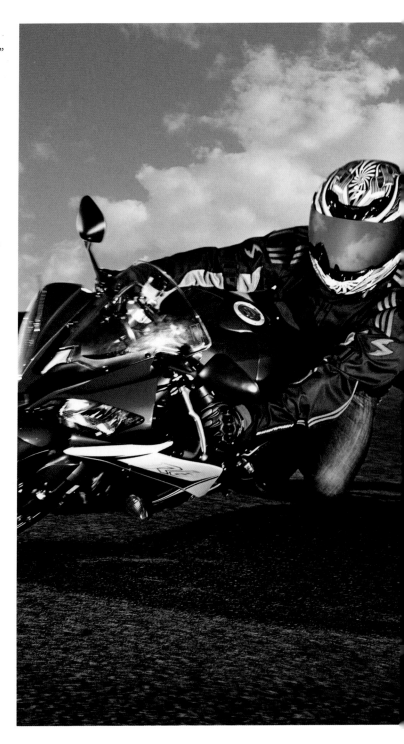

Equipment

Mode: Manual

Lens: EF 24mm f/1.4L II USM

Aperture: f/11

Shutter: 1/125 sec.

ISO: 100

Tripod: Low-rise carbon tripod

Filter: None

Lighting: Multiple strobe flash units

The Setup

To create this picture, I had to find the right sweeping canyon turn that didn't have a distracting background location.

I needed a wide-angle lens and two off-camera strobe units in order to get the shot I was after. One strobe was set up to the camera's left, and the other was set up to the camera's right. Both were set at the same low output so as not to overpower each other. The purpose of this lighting was to create a soft fill light that illuminated the details of the rider but didn't overpower him with light.

I set the camera on a low-rise tripod, because I needed to be able to pan exactly the same with each and every pass the rider made.

How to Shoot It

1. Adjust the exposure triangle settings for a natural, outdoor-looking image.

2. Before you begin shooting, scout your location so you know exactly how you want the shot to look and what directions you should give your subject to accomplish that. When it was almost time to shoot this photo, I walked the route with the rider and took into consideration how he would approach the turn, pass the camera, and exit the turn. All of this had to be done with the utmost safety in mind, and also to be sure he'd follow my directions.

3. Once you and your subject are on the same page about how the shot will be accomplished, you can begin shooting.

4. When shooting action shots in particular, make safety a primary concern. For my shot, I was about 2½ feet away from the rider as he passed by. His speed had to be at a moderate pace so he could safely lean the bike into the turn without concern of falling over—and, of course, I didn't want him to hit me.

When directing action shots, the walkthrough is very important. Every participant has to know his or her role, the timing, and just how *you* want to shoot it.

SELECTIVE FOCUS

Selective focus is a technique you can use to make part of an image very sharp and in focus, while the rest of the frame is very out of focus. The key is learning how to control your depth of field and focus. The easiest way is to put your camera in aperture mode and set the aperture to the smallest f-stop your lens allows, while your camera sets the shutter speed. Once you understand how your "exposure triangle" works—and moreover your depth of field—you can begin to use it to your benefit and create selective-focus images like a pro.

With this photo of a golf shoe, which was part of a collection of interesting images of everyday products, I set out to use a very shallow depth of field and really draw the eye to the center design of the shoe.

Equipment

Mode: Manual

Lens: EF 85mm f/1.2L II USM

Aperture: f/2.8

Shutter: 1/400 sec.

ISO: 100

Tripod: Three-section

Filter: None

Lighting: Ambient with white bounce cards

The Setup

Because ample afternoon lighting was coming through a window to the camera's right side, I decided to use that as my main source of light. To complete the lighting, I used a pair of small white bounce cards on the left side of the camera to reflect the window light back onto the shoe.

The camera must be absolutely still for this type of shot, so I used a sturdy tripod to hold it in position.

How to Shoot It

1. Secure any props you need for the shoot. For this photo, I needed a small platform alongside the window on which to sit my product. I used a light-colored wooden chair because it didn't compete with the darker-brown color of the shoe.

2. Adjust the lighting on your subject. For my photo, I had to move the shoe until I found the best angle for the light to fall on it. I then put a white diffusion cloth over the window to soften the light just a bit more.

3. Secure your camera to the tripod with the appropriate lens in place. Set the exposure triangle to the appropriate settings—this means setting the ISO to a less sensitive value, setting the aperture to its widest setting (smallest number), and adjusting the shutter speed according to the shallow f-stop.

4. Set your focus so your subject will be very sharp in the image. For my photo, I set my focus so only the shoe's logo was sharp and began to shoot.

The exposure triangle is the relationship between aperture, shutter speed, and ISO. Each is represented by a vertex in a triangle, and the perfect triangle is the perfect exposure. If one of the settings is changed and not compensated for by the other two, the exposure of the image will change—it will become brighter or darker or have a different depth of field.

When shooting selective-focus images, it's best to use a medium-range lens because the lens glass will help compress the image even more. You don't want to use a wide-angle lens that has a multitude of focus latitude.

Selective focus is a great way of shooting interesting pictures of everyday tools in a machine shop—do it right, and your results can be classified as fine-art portraits. This photo shows just what the selective-focus technique can do for a normally mundane set of drill bits.

Equipment

Mode: Manual

Lens: EF 100mm f/2.8L Macro IS USM

Aperture: f/2.8

Shutter: 1/125 sec.

ISO: 320

Tripod: Three-section

Filter: None

Lighting: Ambient

The Setup

With this photo, I decided to use my EF 100mm f/2.8L macro IS USM lens, as I knew I'd be shooting in a very low-light situation that's tailor-made for this lens.

I had just enough light coming through the small window in the shop to use as my primary light source. I then positioned the drill bit set on a countertop about 15 feet away from the window so the light coming from the left would reflect on the bits.

From there, I just had to mount my camera on a tripod.

How to Shoot It

1. Adjust the lighting on your subject, if necessary. After the drill bits were in place on the countertop for my photo, I checked again to see if there was a way to enhance the light.

2. Feel free to use other objects to enhance your subject. For this photo, I placed a small, gray toolbox next to the drill bits so it would reflect the ambient light onto them.

3. Once your camera is in place on the tripod, begin composing your shot, making sure you have what you're looking for in terms of lighting and subject position.

4. Set your aperture to its widest setting (smallest number) and adjust your shutter speed accordingly.

5. Set your focus, and begin shooting.

Most people putting profile photos of themselves online will use a relatively simple camera or even a smartphone, which usually produces a flat image. If you want to look your best, use the selective-focus technique with your DSLR to give yourself a high-quality, portraitlike image with a sharp focus on your face.

MACRO AND CLOSE-UP PHOTOGRAPHY

The goal of macro photography is to capture the finest detail in small objects, which sometimes requires a specialized lens. Close-up photography is about simply capturing subjects in close range and doesn't call for any special lenses. They may seem highly specialized at first, but once you master them, you open up a whole new world for your image-taking.

For this image, I sought to show the marathon runner's legs, as well as the specialized shoes she was wearing. But I also wanted to catch a glimpse of the surrounding area and the vast hills in which the runner trains.

Equipment

Mode: Manual

Lens: EF 16–35mm f/2.8L II USM

Aperture: f/5.6

Shutter: 1/500 sec.

ISO: 100

Tripod: None

Filter: None

Lighting: Fill flash

The Setup

Because this particular day featured a bold blue sky, I didn't need any specialized equipment—just what I could carry on my back. The blue sky also led me to use a fill flash mounted on my camera as an additional light source and to show more detail in the shoes.

I chose to use a wide-angle zoom lens and to hand-hold the camera for the shot. Because I was looking for a low-perspective wide-angle setup, I brought a small towel so I could lie on the ground.

How to Shoot It

1. Attach your lens to your camera. Check your exposure readings and set them accordingly.

2. Mount your flash unit. Because you're adding more light to the scene, check your exposure readings again and reset as necessary.

3. Lie down and begin to compose the shot.

4. Once your shot is composed, have your subject walk through the shot so you can confirm your composition and check your settings. For my photo, I had the runner step in and out of frame repetitively to get a "realistic" pose of her standing and to check my focus.

5. With your focus set, begin clicking away.

Because of the growing popularity of macro photography, many DSLR cameras today have a built-in macro mode. This mode changes the exposure meter settings and focus zones to accommodate for a macro shoot.

Be cautious of your lens choice when shooting anything close-up. Many wide-angle lenses will distort the subject, making it appear unrealistic and have unnatural shapes.

I was recently asked to shoot portraits of a famous motorcycle builder. During the time we shot together, I also captured a collection of both close-up and macro images of the various tools and machinery in his shop. This shot of a well-worn, adjustable wrench speaks volumes about a life spent building things.

Equipment

Mode: Manual

Lens: EF 100mm f/2.8L Macro IS USM

Aperture: f/2.8

Shutter: 1/250 sec.

ISO: 1250

Tripod: None

Filter: None

Lighting: Ambient

The Setup

Being in a closed-door machine shop, I had to pay close attention to all the available light coming in through the windows.

I knew I'd need to have enough distance between me and the subjects to allow as much light on them as I could while still having "macro" capabilities, which is why I chose a special type of macro lens.

Macro photography allows you—and those viewing your image—to see details on a small object that are usually overlooked. Whether it's an insect that suddenly looks like a giant, the grainy details of a leaf, or small scratches on a watch crystal, macro photography can open up a world you've never seen before.

How to Shoot It

1. Compose your shot. There was an overhead window about 20 feet away from my subject, but because I couldn't move the toolbox, I began by setting up my camera into the composition I wanted.

2. Once you have composed your shot, begin going through a series of exposure adjustments to create the image you're looking for.

3. Set your aperture and adjust your shutter speed based on the lighting for where you're shooting. For this image, I set my aperture to its widest setting (smallest number) and adjusted by shutter speed according to the ambient exposure reading of the machine shop.

4. Set your focus very shallow so it has part of your subject in focus while allowing anything else in the image to be visible but supportive of your subject as the main character. For my photo, I kept part of the adjustable wrench in focus and allowed the other tools to play a supporting role.

5. Make sure you capture the fine points of your subject in your shots. My image was geared toward the smallest details on the head of the wrench, including the blue flecks of paint that had stuck to the metal.

GETTING CREATIVE WITH FILTERS

Filters can do a multitude of things for your images, from adding a little color to a sunset to decreasing reflections. More advanced filters can even correct the actual colors in an image. In today's digital photography age, most filters can be added to your photos via your computer, with a couple exceptions. The following examples will walk you through those filters.

For this first example, I wanted to show wedding dresses shot through a glass window at midday, with all the normal street-side reflections. By using a polarizing filter, I was able to drastically reduce the reflections that would have been difficult if not impossible to move on the computer.

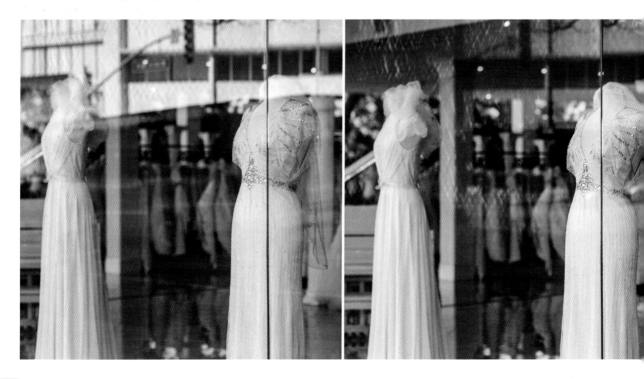

Equipment (Shot 1)

Mode: Manual

Lens: EF 85mm f/1.2L II USM

Aperture: f/5.6

Shutter: 1/500 sec.

ISO: 100

Tripod: None

Filter: None

Lighting: Ambient

Equipment (Shot 2)

Mode: Manual

Lens: EF 85mm f/1.2L II USM

Aperture: f/8

Shutter: 1/500 sec.

ISO: 100

Tripod: None

Filter: Circular polarizing

Lighting: Ambient

The first filter many photographers, especially ones shooting landscapes, typically buy is a polarizing filter because of its ability to improve the contrast and vividness of many photos. Through rotation, a circular polarizing filter varies the amount of polarization by allowing some light waves to pass through while blocking others.

The Setup

Because I was looking for a reflective situation, I brought along a circular polarizing filter to use in the shot. I also chose to use a portrait lens and to hand-hold the camera for the shot.

I found a local wedding retailer and used their sidewalk window to shoot a pair of dresses on display.

How to Shoot It

1. Attach your lens to the camera. Look at your exposure readings and set them accordingly. *Don't attach the filter for the first shot.*

2. Stand at an angle from the reflective surface and take a photo that shows the reflection in full. For the first shot, I took a photo of the dresses on display that illustrated a horrible reflection of the street behind me.

3. For the second shot, attach the circular polarizing filter and adjust your exposure settings to accommodate for the decreased amount of light.

4. While looking through the camera, rotate the circular filter and watch as it reduces the reflections on the surface. Once it's set to reduce the glare and reflection, take the second shot.

When shooting with a polarizing filter, remember to adjust your exposure once you attach it, as it will darken your photos. Make sure to readjust your exposures to the proper settings once you remove it, too.

A neutral density filter is simply used in increments to decrease the amount of light in your photo without having to adjust your other camera settings, such as shutter speed, aperture, or ISO. The biggest advantage of this type of filter is it allows you to reduce the intensity of the light in your picture equally and add or subtract a bit of the denseness in your image. For this example, I sought to show the effect of a neutral density filter on a scene of water cascading over the rocks.

Equipment (Shot 1)

Mode: Manual

Lens: EF 85mm f/1.2L II USM

Aperture: f/22

Shutter: 8 sec.

ISO: 100

Tripod: Three-section

Filter: 2-stop neutral density

Lighting: Ambient

Equipment (Shot 2)

Mode: Manual

Lens: EF 85mm f/1.2L II USM

Aperture: f/22

Shutter: 2 sec.

ISO: 100

Tripod: Three-section

Filter: None

Lighting: Ambient

Neutral density filters typically lessen the amount of light passing through them without changing the nature of the light—in other words, they keep the colors true. Some can block out nearly all the light and give image results that wouldn't be possible without them. Others only block a portion of light, yet they can help shape images in a way that's superior to what can be done on a computer.

The Setup

The setup is identical for both shots, with the only adjustments being to my exposure settings to accommodate for the addition and the removal of the filter. I set up my tripod, attached the camera, and put on the lens.

From there, I composed the shot to illustrate the water flowing over the moss-covered rocks.

How to Shoot It

1. To make the water look like it's speeding past, use a very slow shutter speed. Compensate by adjusting your aperture to allow for a proper exposure.

2. Attach the filter for the first shot. I used it to cut out two stops of ambient light and to shoot at a longer exposure without overexposing my shot. Shoot the image.

3. Move on to the second shot by first removing the filter.

4. Take an additional meter reading and adjust your exposure to accommodate for the removed filter.

5. Once your settings are secured, take the second shot. The shot may look similar, but you should notice a variance in the density and texture of each shot.

WORKING WITH REFLECTIVE AND MIRRORED SUBJECTS

Shooting subjects with reflective and mirrored surfaces might seem quite problematic at first, but with both practice and patience, you can create artful photos that will elicit a "wow" reaction from family and friends. The trick to shooting reflective and mirrored subjects is knowing when to shoot at opposing angles, a technique that will actually enhance your photo. Once you learn the basics, you can let your vision and creative bent take over.

In this photo of a surfer's car parked near the ocean at sunset, I saw an opportunity to use reflective imagery to tell the story of the quintessential lifestyle of a traveling surfer, as his car sat basking in the golden light of a beautiful California sunset.

Equipment

Mode: Manual

Lens: EF 100mm f/2.8L Macro IS USM

Aperture: f/4

Shutter: 1/1250 sec.

ISO: 100

Tripod: None

Filter: None

Lighting: Ambient with a white bounce card

The Setup

I positioned the camera so the golden sunset would reflect down the side of the car and along the surfboard's edge and fins. I then placed a white bounce card to reflect light back onto the subject from camera left.

I used a medium-length lens so the background was entirely out of focus, drawing all the attention to the reflective surface on the car.

How to Shoot It

1. Set up your camera at a side angle so your reflection can't be seen on your subject and set your exposure. For this photo, I set my camera at a side angle to the back of the car so my reflection wasn't seen and chose an exposure setting that allowed for a rich and vibrant golden sunset.

2. Choose the focus of your image. For mine, I made sure to focus on the rear of the car and the surfboards, as I wanted that to be the focal point of the image.

3. Begin shooting. Because you're shooting at a faster shutter speed, you can hold the camera in your hands without worrying about the shaking that can cause blurriness in the final image.

4. When shooting outdoors, make sure you're aware of how the lighting will change as you shoot. For this shoot, I had to work quickly, as the setting sun was quickly changing. I shot a variety of compositions in both the landscape and portrait formats and walked away with the shots I had envisioned.

When deciding what to photograph using reflection imagery, it's often better to choose subjects that have curves or unusual shapes because this shaping will add definition to your image. It's also why people aren't great subjects to shoot in this manner.

Reflective photography doesn't easily lend itself to the use of a flash. Flashes can often produce a lot of glare or bright spots that will ruin your image. If you must use any kind of flash or strobe, always be sure it fires a very low light and at an angle that won't be noticed in the final result.

In this image of a watch and a wedding ring, I wanted to show both perspective and attention to detail in a magnified macro view. It's a different kind of mirrored image, because you are shooting close up and with selective focus. If you do it right, you'll really give everyday objects a life of their own and create an image people will want to see.

Equipment

Mode: Manual

Lens: EF 100mm f/2.8L Macro IS USM

Aperture: f/5.6

Shutter: 1/200 sec.

ISO: 320

Tripod: Three-section

Filter: None

Lighting: Strobe flash unit with a white bounce card

The Setup

Because I knew I would need to be close up and focus closely on my subject, I chose a macro lens.

To get the shot I wanted, I needed a small table to shoot on, a 2 × 2-foot black velvet backdrop, and a 12 × 12-inch mirror to lay in front of the backdrop. For my lighting, I used a small strobe light source and a white bounce card.

From there, I set up my tripod and camera.

One of the best ways to shoot small objects like a watch or ring and keep them from shifting is to use a product called museum wax. This soft, gel-like putty holds lightweight products in place. You can typically find museum wax at many local hardware stores.

How to Shoot It

1. Set the background and mirror in place.

2. Put your subject in position. For the ring and watch in my photo, I used a bit of museum wax to make sure they stayed securely in place.

3. Place a diffused light source just off camera right, and set up a soft white bounce card just out of frame on camera left.

4. Set your tripod, attach your camera, and connect the strobe's sync cord to the camera.

5. Set the proper exposure value on the camera and double-check your focus. Begin shooting.

6. When shooting, feel free to move your camera around to compose different shots. Throughout my shoot for this photo, I moved the camera several times to compose a variety of different shots, which also required me to adjust and tweak the lighting and, of course, the product.

When using a mirror as a reflective piece for a photo, always make sure the mirror is completely clean. Any spots, scratches, or streaks on the mirror can easily translate to the image and cause it to lose quality and originality.

PANORAMIC PICTURES

Panoramic photography is the art of capturing images with elongated fields of view—both horizontally and vertically. It cannot only produce some beautifully striking images, but also can be a joy to shoot and extremely fulfilling when you achieve the desired results. The human eye normally views only 80 to 120 degrees when looking directly at a scene. By contrast, a well-executed panoramic photo can capture from 180 to 360 unbroken degrees of the same scene. That's what makes these photos special.

The DSLR is the perfect tool for taking panoramic images, so shooting this type of image is a skill well worth mastering. In fact, shooting panoramic images is not all that difficult once you understand the basics of setting up and taking the shot.

This panoramic shot is of a pickup truck on a dry lake bed in California's Mojave Desert. When I decided to take this photo, I wanted to illustrate the striking vastness of the empty lake bed with the elongated late afternoon shadow.

Equipment

Mode: Manual
Lens: EF 14mm f/2.8L II USM
Aperture: f/22
Shutter: 1/40 sec.
ISO: 100
Tripod: Tripod capable of setting up low to the ground
Filter: 1-stop neutral density
Lighting: Ambient

The Setup

I chose to take this shot with a very wide-angle lens. The 14mm lens offers an astounding 114-degree angle of view and exceptional sharpness at the outside edges of the frame.

I set up my tripod at a low setting, about 20 inches from the ground, so it would match the height of hills in the background with the horizon line of the truck. Had I elevated the camera position more, it would have resulted in the hills dwarfing the truck. With the camera set too low, it would have allowed too much of the underside of the truck to become prominent.

Unless you're looking for a special effect, it's important to keep your tripod and camera level, especially if you're taking a series of shots. If you are panning and the camera is at an angle, the objects in the distance can fan out and distort, making it difficult to overlay. If you don't feel you can do this by eye, purchase an inexpensive spirit-level attachment, which attaches to the hot-shoe of the DSLR and tells you if the tripod is level.

How to Shoot It

1. Make sure your setup at the location is the way you want it. I waited until the sun was low in the western sky, casting that elongated shadow at the back of the truck.

2. Check to see if the horizon line is balanced.

3. Set the focus.

4. Create the depth of field by the appropriate aperture and ISO setting, both based on the lighting of the late afternoon. I used a neutral density filter (1 stop) so I could maintain a proper exposure while using the settings I chose. A neutral density filter "cuts" the amount of light entering the camera in lieu of adjusting shutter speed, aperture, or ISO.

5. Use a sandbag to weigh down and stabilize your tripod so no shaking occurs during the exposure time. Make one last check to be sure the lighting conditions haven't changed, and you are ready to shoot.

Note: *When you first begin shooting panoramas, take more than one shot. Experiment from different points of views and angles and compare the results. This will help you decide just what you want the next time out.*

Many beginning photographers think of panoramas only in terms of horizontal scenes. But you can also shoot beautiful verticals, such as a dropping waterfall or even a tall building. You can turn your camera on its side or keep it on a horizontal plane. The same principles of shooting panoramas apply. You just have to learn to shoot up and down, instead of across.

As soon as I saw this beautiful bay on Krk Island in Croatia, I knew I wanted to shoot a panorama of it—especially when I noticed the oncoming storm that's visible on the left side of the frame. With part of the bay radiant and glowing and the inside of the bay darker and gloomy, I thought it made for a great storytelling picture.

Equipment

Mode: Manual

Lens: EF 70-200mm f/2.8L II USM

Aperture: f/22

Shutter: 1/60 sec.

ISO: 400

Tripod: Tripod set at waist height

Filter: None

Lighting: Ambient

The Setup

I chose to take this shot with a telephoto zoom lens, not the atypical wide-angle lens that everyone thinks you need to create a panoramic image. The 70 to 200mm lens offers great latitude in focal length while creating razor-sharp images. With a longer telephoto zoom lens, I knew I would need to shoot a series of at least five photos to show the whole scene. I then planned to overlay them on the computer to create my final panoramic image.

I set up about 100 feet from the lake. I needed to be up high enough so when I panned left to right, I could keep the same horizon line and still get the entire bay into the shot.

How to Shoot It

1. Set up your camera on a tripod, and balance your horizon line in the middle of the frame.

2. Select marker points in the background to watch for as you pan your camera to the right. For this image, I made sure that each marker point was at the edge of each frame; this allowed me to know where to stop my left-to-right pan and shoot another picture.

3. As you stop at each marker point, click the shot and proceed to the next marker point. In all, I shot five photos to create this picture.

4. When you complete the shot, repeat the sequence. I did this over and over to give myself plenty of options to select from once I got back to my computer.

5. Once you upload the shots to your computer, depending on your photo-editing software, you can overlay the photos manually by creating a canvas wide enough to drop them in or have the software merge your images automatically.

Don't confuse panning for a panorama with shooting action shots—there's no need to rush. Take your time when panning and pinpoint your marker points. It's more important to snap each photo in the right spot than to snap them quickly. Slow and relaxed beats fast and furious anytime.

STUDYING LIGHT

One of the biggest challenges for beginning photographers is learning how to study light and being able to judge just how that light will affect their pictures. Once you have a grasp of the full use of light, you can really explore your craft. There's no getting away from it—understanding how lighting works is fundamental to your creative process.

This sequence of five images illustrates how the light reacted, reflected, and changed as I positioned it or moved it across the subject plane—in this case, a statue. Once you've tried this yourself, you'll be able to really "see" light and how it affects your image in a whole new way.

Equipment

Mode: Manual

Lens: EF 85mm f/1.2L II USM

Aperture: f/2.8

Shutter: 1/160 sec.

ISO: 100

Tripod: Three-section

Filter: None

Lighting: Strobe flash unit

The Setup

I first set up the statue. I then set up my camera and tripod and made all the necessary exposure adjustments.

I set up a light stand that had a strobe light with a snoot attached to it and affixed it to a boom arm, so that in the middle of my sequence I could extend it out over the statue while keeping the equipment out of my frame.

When studying light and gathering your thoughts about how you'll shoot a particular scene, you must also pay attention to the type of surface. Is it reflective, shiny, or mirrored? Each of these scenarios will add various elements to the equation and change the overall look and feel of the final image.

How to Shoot It

1. Check the requisite exposure and make any adjustments. Keep the same exposure and focus settings throughout the shoot.

2. Set up the lighting for the first position. Start with the light directly to the left of and at the same height as the subject—in other words, at the 9:00 position. Snap a picture.

3. Lift the light and rotate it downward slightly to mimic the light being at the 10:30 position. Snap a picture.

4. Move the light to the high noon position, and snap a shot.

5. Keep moving across the plane of the subject, and reset the light to the 1:30 position. Snap a picture.

6. Finally, set the light up at the 3:00 position.

7. Compare the results.

Always pay attention to the angle and direction of light. A wrong choice can alter the mood and feeling of an image; a right choice can only enhance it.

I photographed the same scenario as the previous example, with the same lighting setup, subject, and material. However, this time I wanted to show how light reacts when a bounce card or reflector is added directly opposite the light source.

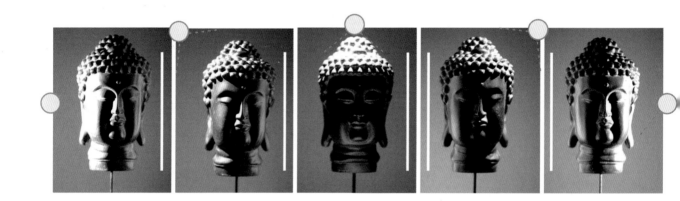

Equipment

Mode: Manual

Lens: EF 100mm f/2.8L Macro IS USM

Aperture: f/2.8

Shutter: 1/160 sec.

ISO: 100

Tripod: Three-section

Filter: None

Lighting: Strobe flash unit with a white bounce card

The Setup

The subject and camera were already in place from the previous setup. I also kept the same exposure adjustments and lighting setup.

For this sequence, though, I added a 2 × 3-foot white bounce card to the mix and used it to reflect light back onto my subject so I could illustrate the nuances from the single light source.

How to Shoot It

1. Start as you did in the previous example, but add another light stand and attach a white bounce card to it with a super clamp. (The clamp looks and acts like a heavy-duty clothes pin to keep the card in place.)

2. Repeat the same lighting positions as in the previous example, but this time add a white bounce card directly across from the light. For example, if your light is at the 9:00 position, have your bounce card at the 3:00 position.

3. Compare the results and see what difference there is between both the pictures in this sequence and the pictures without the bounce card from the previous example.

Studying light should become second nature for a photographer. When you're outdoors, always check out the light around you and how it might apply to a photo. Even when you're indoors at different venues, make it your business to think of the lighting in terms of your next photo—how you would use it, enhance it, and make it work for you.

Natural light can change in a matter of minutes. Whether you're shooting at sunrise or sunset—or on a day when the sun is in and out from behind the clouds—you have to be ready to shoot when the light is just the way you want it. If you fumble around with your setup and then take too much time deciding on your exposure settings, the light may suddenly change—and with it, the whole mood of your shot. So watch the light and be ready to act quickly.

CREATING MOTION BLUR

When creating motion-blur photographs, you'll learn to apply a variety of techniques that will allow you to make great-looking images from subject matter that otherwise might look boring and mundane. The most common technique is to slow your shutter speed down to 1/60 or 1/30 and let your subject just pass through the frame, which blurs the subject. You can also keep that same shutter speed setting and pan with your subject, thereby allowing your background to become blurry while your subject remains relatively sharp. However you decide to execute the photo, you'll create a very unique image.

In this shot of the mountain biker, I had to improvise due to lackluster weather conditions and rather unflattering overhead lighting. Instead of looking to create beautiful scenic shots, I switched to creating motion blurs.

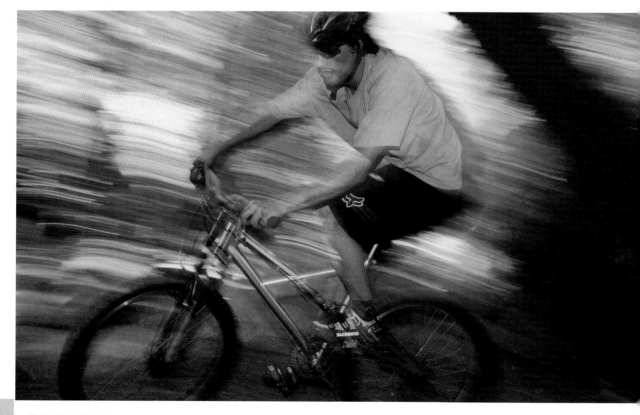

Equipment

Mode: Manual

Lens: EF 24mm f/1.4L II USM

Aperture: f/8

Shutter: 1/8 sec.

ISO: 100

Tripod: Three-section

Filter: None

Lighting: Strobe flash unit

The Setup

Choosing the location was important. I found a tree-covered trail with a sweeping corner that would be ideal when the bike rider passed through it.

Because the lighting was directly overhead and less than desirable, I decided to go under a canopy of trees and create my images there. This allowed me to use the trees as a filter of sorts so the subject and I weren't under direct sunlight.

Fortunately, I had a tripod on hand, which allowed me to pan while keeping my shutter speed very slow. I also had a battery-operated strobe unit with me to add light back into the scene as needed.

You can pretty much use any lens you have to create motion-blur images. All of them offer a variety of effects, so the best thing to do is experiment with what you have. Remember, have fun with it and don't be discouraged if the images aren't exactly what you want the first time out.

How to Shoot It

1. Once you settle on the location, set up your camera with the desired wide-angle lens, shutter speed, aperture, and flash output.

2. Set up your tripod, and balance and secure it. Check your composition and right-to-left panning capabilities.

3. Next—and this is important—set your focus so your subject will be razor sharp, regardless of the motion-blurring effect you want to create.

4. Figure out with your subject what position you want him or her to be in when you shoot. Once everything was set to take this shot, I asked my subject to do a few practice passes so he and I could coordinate the perfect position for him to be in when I clicked the shutter button.

5. Pan carefully on your subject as you hit the shutter button. For me, it was just a matter of panning on the mountain biker as he rode past.

Note: *Because no experimental shots are perfect each and every time, I did a series of shots from this setup and bracketed my exposures, shutter speed, and flash output power. That means going both up and down three stops, in one-stop increments, and shooting the same shot at all settings. You can also bracket in 1/3-stop increments, which is the method most often used.*

When I saw this stream running alongside the green foliage, I suddenly had an idea to change the look. By creating motion blur, I wanted to make the water appear as though it was rushing by at a high speed.

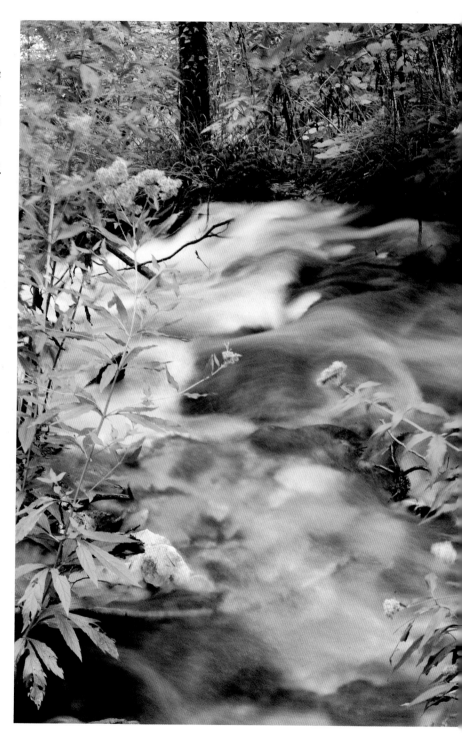

Equipment

Mode: Manual

Lens: EF 85mm f/1.2L II USM

Aperture: f/22

Shutter: 2 sec.

ISO: 100

Tripod: Three-section

Filter: Polarizer

Lighting: Ambient

The Setup

To execute this shot, I had to be sure I had a spot where the trees and foliage would remain absolutely still during my long exposure—that way, I could use them in my composition to help it appear the water was rushing by at high speed.

I had a tripod on hand to allow me to use my shutter speed at a very slow setting. Without a tripod, I wouldn't be able to hold the camera steady enough at that setting to execute the shot. I also needed a polarizing filter to not only cut down on the light a bit, but also to help create a deeper richness to the green foliage.

How to Shoot It

1. Once you find a location, set up and stabilize your tripod. Attach your camera to the tripod.

2. Choose the appropriate lens. I decided to shoot with an 85mm lens, as it gave me the best composition for the location. Attach the polarizing filter and spin it around until it gives you the desired polarization effect you need. Adjust your shutter speed to a very slow setting, and set the aperture to accommodate for a proper exposure.

3. Compose your shot so you get the motion blur you desire. When I composed my shot, I set my focus so the foliage in the foreground would be razor sharp. Any movement in the foliage would have ruined the motion-blur effect.

4. Make sure your camera is very stable before you shoot. For this shot, I added a digital cable release so my hand didn't shake the camera by pushing the button.

Remember, there's no one way to do anything in photography—and that includes creating motion-blur pictures. I'll often climb up on a ladder and shoot a subject from directly overhead, panning with my subject from above. Sometimes, I'll even keep the camera stationary and then, in lieu of panning, I'll rotate the camera, creating a radius motion-blur effect. Experiment and see what you get. You can even try shooting vertical motion blurs, but make sure you always use your tripod to do them.

SHOOTING SEQUENCES

Shooting sequences is a fun and rewarding technique that can be done in several different ways. You can shoot a sequence of images while you're stationary and allow the subject to pass through your frame, or you can pan with them as the action unfolds. Both are acceptable means to capture the activity and can produce striking results.

In these sequential images of a surfer riding a wave, I wanted to capture a continuous sequence of riding a large wave from takeoff to finish, including part of the ride inside the "tube" formed by the wave.

Equipment

Mode: Manual

Lens: EF 600mm f/4.0L IS II USM

Aperture: f/8

Shutter: 1/1000 sec.

ISO: 200

Tripod: Three-section

Filter: None

Lighting: Ambient

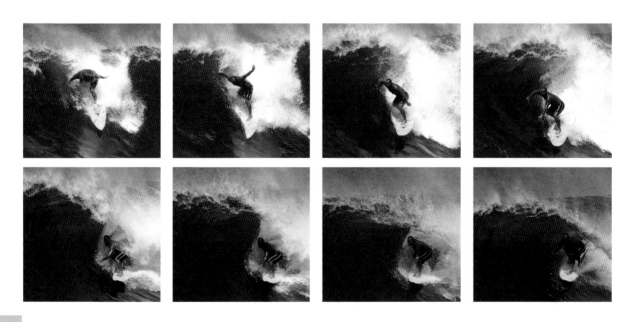

The Setup

Because the surfer was about 100 feet from the beach and my camera, I chose to use a 600mm super telephoto lens. I mounted the large lens on my tripod and then balanced the horizon line by leveling out my tripod. This is absolutely necessary, because a tripod that isn't level will produce horizon lines that are tilted when panning from right to left.

Once the gear was set up and ready to go, I set my aperture and shutter speed to the appropriate setting for a well-lit and balanced exposure, taking into account the natural light, as well as the color and reflective properties of the water.

From that point, I did a few practice pans from right to left to make sure everything was dialed and ready to go when the action started.

How to Shoot It

1. Double-check your composition to make sure you can capture the entire sequence. For my photo, I made sure I could capture the entire ride down the wave from beginning to end.

2. Set your focus to "infinite" so your subject will be razor sharp. That allows you to just keep your subject in your autofocus brackets inside the viewfinder throughout the sequence and still have it remain in focus.

3. Pan slowly as you shoot, making sure not to jerk the camera or make any fast movements.

4. Time the shutter clicks so they are smooth and even from start to finish.

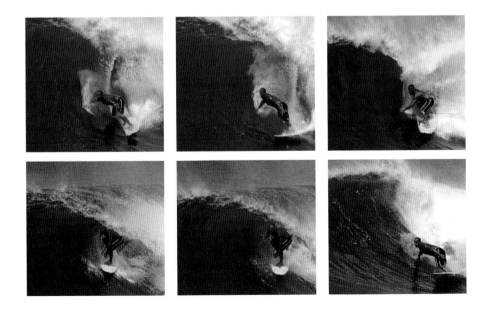

The objective of this shoot was to create a single image of a motorcyclist doing a backflip on his bike as he jumped from one barge to another, while capturing all of the action in a sequential form. In all, I shot 23 images; I then stitched them together on the computer to make a single photograph.

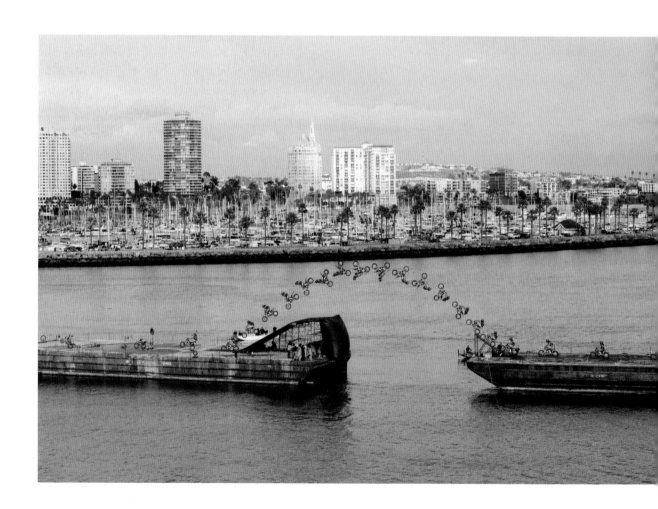

Equipment

Mode: Manual

Lens: EF 70–200mm f/2.8L II IS USM

Aperture: f/8

Shutter: 500 sec.

ISO: 100

Tripod: None

Filter: None

Lighting: Ambient

The Setup

To get this once-in-a-lifetime shot, I had to set up on the top platform of a nearby boat to acquire the shooting angle I needed. I couldn't use a tripod, so I had to hold the camera by hand and use a fast-enough shutter speed to capture the action.

Because this sequence was being shot on a boat in the middle of the harbor, I also had to pay close attention the boat swaying up and down from both the tidal movements and other boats sailing past us.

Once my location was secure, I set up my telephoto zoom lens and checked my composition.

How to Shoot It

1. Choose a lens with an image-stabilization feature to keep the picture from becoming blurry from any unforeseen camera shake. For this sequence, I chose to shoot with an EF 70–200mm f/2.8L II lens, which offers such an image-stabilization feature.

2. Because you're at a slight angle to the action, set your aperture to f/8. This assures you have enough depth of field to have the entire side-to-side frame in sharp focus.

3. Once the action begins, keep your camera very still—don't pan—and let the action pass through your frame. As the action was taking place during my shoot, I was able to capture 23 images in the span of about 4 seconds. The camera drive is capable of shooting from six to eight frames a second.

4. Once back at the computer and after all of your images are downloaded, begin to stitch them together to produce the final image. I used an advanced photo-editing software and seamlessly overlaid each of these images together by myself, but you can find editing software that will do this for you automatically.

Along with a lot of light, the only way to properly freeze the action for a sequence is to use a fast shutter speed. You have to shoot at 1/500 of a second and above to freeze your subject or subjects without blurring.

Though I shot this sequence without a tripod, it takes a great deal of practice to do this successfully. Whenever possible, use a tripod when shooting sequences—any camera shake will shift the frame and making stitching difficult. With the tripod, each frame stays in place, which makes photo stitching much easier.

TAKING HD VIDEO WITH YOUR DSLR

Without a doubt, one of the best features added to the DSLR in recent years is the capability to shoot fantastic high-definition (HD) video. Because I can only show you a still picture of the action, my setup for each video goes step-by-step through shooting the video, with the picture illustrating the angle from which I shot it.

For this first setup, I wanted to capture video footage of an off-road truck race and show the most intense action I could. I did this by capturing a scene of a subject passing through the frame without moving my camera.

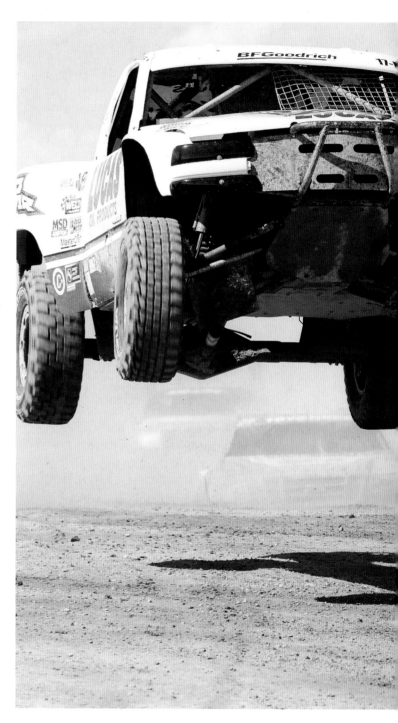

Equipment

Mode: Manual

Lens: EF 400mm f/2.8L II IS USM

Aperture: f/11

Shutter: 30 fps

ISO: 320

Tripod: Three-section with fluid head

Filter: None

Lighting: Ambient

The Setup

As with any shot, I had to look for the best angle from which to shoot. With this shot, my priority was to capture the trucks in mid-flight over a jump. To accomplish my vision, I chose to use a super-telephoto lens and let the subject pass through the frame coming at me.

Because I was looking for a more intense perspective that would make the truck look like it's higher off the ground and coming right into my camera, I set up my lens about 2 feet off the ground, just off to the side of the race course.

How to Shoot It

1. After setting up your gear, check your composition.

2. Set the exposure settings according to the specs for shooting video.

3. Set your frame rate (video equivalent to the shutter speed) to 30 frames per second (fps) and your aperture to f/11.

4. Preset your focus at a predetermined distance.

5. You can now begin shooting your video. When the action begins, simply push the record on/off button and capture the action. Once you're finished shooting, push the button again to stop the recording.

The shutter speed in photography and the frame rate in video capture both provide the same results to your final product. However, the most common frame rate speeds for a DSLR are 24 and 30 frames per second, while the typical shutter speed is one frame at a fraction of a second.

When shooting video—and depending on if your camera allows you to adjust your frame rate setting—try shooting in varying frame-per-second speeds (24, 30, 60, or more if you can) and see if you like slow-motion or sped-up versions of your shots.

Like in the previous example, I wanted to illustrate the intense racing action while shooting video at an off-road truck race. This time, though, I accomplished this by panning left to right and following the subject.

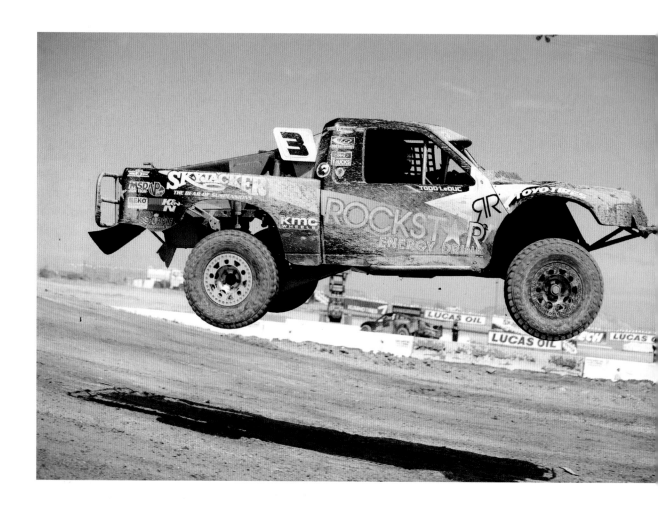

Equipment

Mode: Manual

Lens: EF 16–35mm f/2.8L II USM

Aperture: f/11

Shutter: 30 fps

ISO: 320

Tripod: Three-section with fluid head

Filter: None

Lighting: Ambient

The Setup

With this particular setup, I wanted to shoot left-to-right panning shots as the trucks flew past me. To do this, I needed a fluid-head tripod, which is made for smooth movements when shooting video. Because of the new angle I was shooting, I also needed a wide-angle zoom lens.

How to Shoot It

1. Find a location from which to shoot safely. For my video, I had to make sure I was not close enough to the action that I could be hurt by the trucks or cause the drivers injury.

2. Set up your tripod, mount your camera with the lens secured, and balance your horizon line. Do a few left-to-right pans to make sure your frame from start to finish has a balanced horizon line or is the way you want it.

3. Double-check your exposure settings and do a few test shots. Pay close attention to where the action is so you can preset your focus and not have to worry about following focus on your moving subject.

4. Once the action starts, you can begin shooting.

If you're taking video of continuous action and don't have just one window of time to shoot, practice panning several times to make sure you keep the subject squarely within the frame. When you're ready, you can then begin shooting for real.

Most inexpensive DSLR cameras have automatic focusing when you're shooting video. On mid-tier and higher-end models, however, you have to contend with the focusing yourself. If you have one of those models, you can purchase any of the numerous focusing accessories available on the market to help you out.

TRANSFERRING YOUR IMAGES

By now, you're well on your way to shooting beautiful images. But there's still one more thing you need to do: process your images.

Getting your images from the memory card in your camera is not all that difficult. I don't want to go into too much detail about the various software and techniques that can be applied to your images, but I do want to give you a basic idea of what happens when you get your images on your computer.

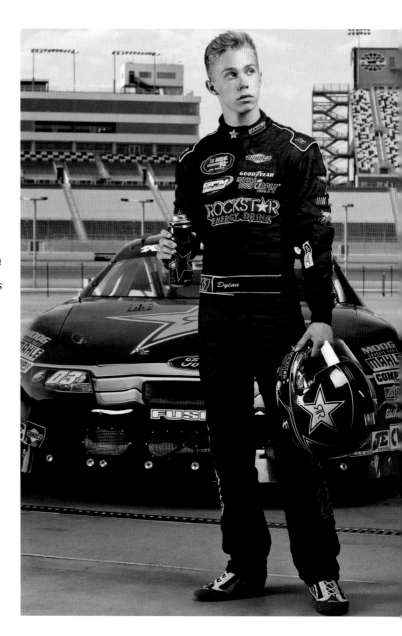

The Setup

To transfer my images from the memory card to the computer for processing, I first make sure I have my memory card reader and my computer nearby and operational. My memory card reader is plugged into one of the ports on my computer. (My ports and readers are USB 3.0, but yours may be USB 2.0 or even Firewire.)

How to Transfer the Files

1. Set up a destination folder on your desktop so you know where the files are going.

2. Once you've created the destination folder, make an identical backup folder somewhere else, just in case something happens to your computer or its software. I put mine on an external hard drive that's portable and not always linked to my computer. That way, I always have a backup should an issue arise. (And trust me, it always does.)

3. Depending on how meticulous you are, you can make subfolders with the name of each of your final file types. For example, I make a primary folder that may read "Day in the Park w/ AMG." Inside that main folder that holds all of my pictures from the shoot, I make another couple of subfolders, such as "RAW" for my original RAW files and "Finals" for all of my processed files.

4. Put your memory card into the card reader; it should automatically link to your computer. Once you see the card reader icon on your desktop, you're ready to go.

5. Open your destination folder and the memory card folder that contains your pictures. Highlight the images and drag them over to your destination folder. A dialog box should pop up on your screen letting you know the files are transferring.

6. Once you've gotten your images to your destination folder securely, remove the memory card icon from your desktop and disconnect the card reader cable from your computer.

7. When you're ready to view your images in the destination folder, simply open the image-editing software on your computer and open a file.

8. You can now review or adjust your images!

If you've captured your images in a JPEG format, nearly every computer will automatically open your file and you can see what you've got. However, if you've captured your images in a RAW format, you need a specific software plug-in for your computer's software to read the file format.

INDEX

A

B

C

M

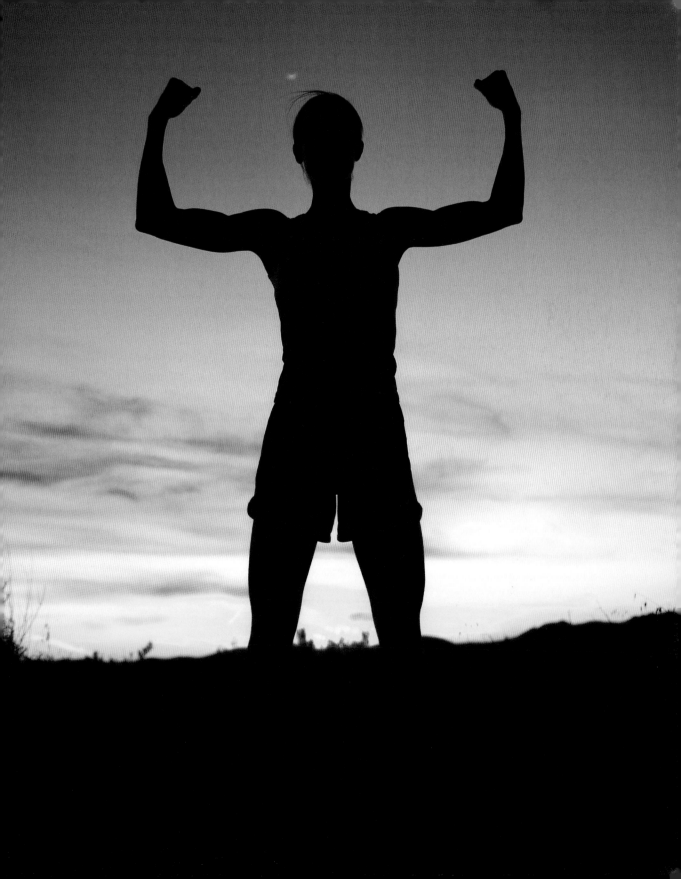

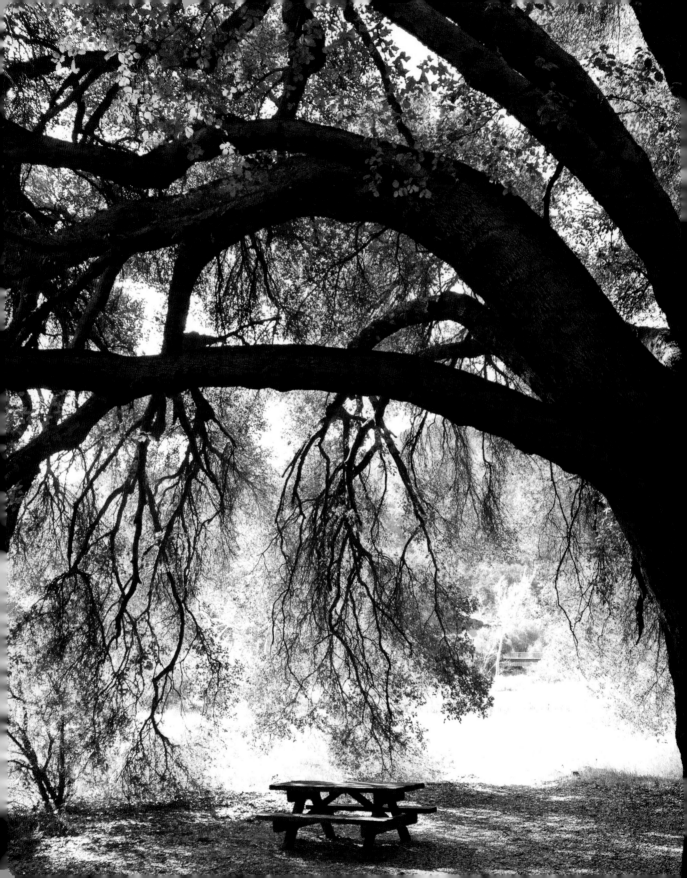